Ann + John W. K...
9.12.87
Cape May, N.J.

The Travelling Photographer's Handbook

Julian Calder and John Garrett are top international photographers with more than a million miles of experience on assignments for magazines like *Time, Paris Match* and the *Sunday Times*.

Whether you are a professional who travels to photograph, or a keen amateur who travels for business or pleasure, this comprehensive and practical guide to taking better pictures will enable you to benefit from their expertise.

Illustrated with some of their most breathtaking pictures, *The Travelling Photographer's Handbook* anticipates – and solves – virtually every problem you are likely to meet, from preparing for the trip right up to the moment of shooting and beyond.

Fielding's
TRAVELER'S PHOTOGRAPHY HANDBOOK

Written and photographed by
Julian Calder and John Garrett

Fielding Travel Books
℅ William Morrow & Company, Inc.
105 Madison Avenue, New York, N.Y. 10016

First published in 1985 by Pan Books Ltd.,
Cavaye Place, London SW10 9PG, England.

Library of Congress Cataloging in Publication Data

Calder, Julian.
 Fielding's traveler's photography handbook.

 Includes index.
 1. Travel photography—Handbooks, manuals, etc.
I. Garrett, John. II. Title.
TR790.C36 1985 778.9′991 85-10334
ISBN 0-688-04219-8 (pbk.)

Printed in Great Britain

1 2 3 4 5 6 7 8 9 10

Contents

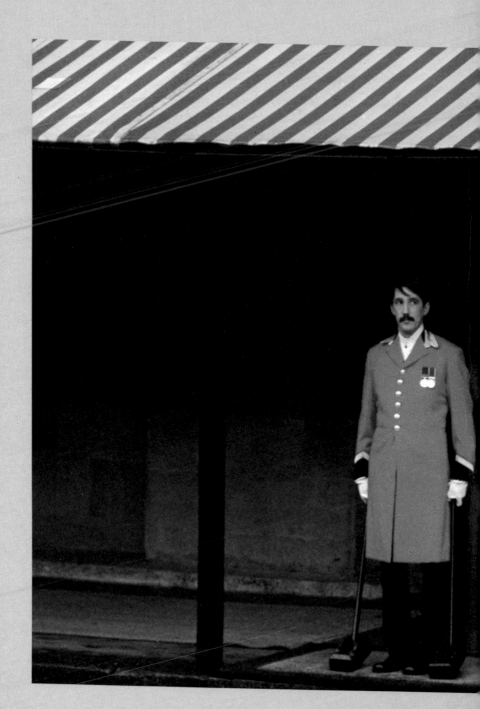

London

Venice

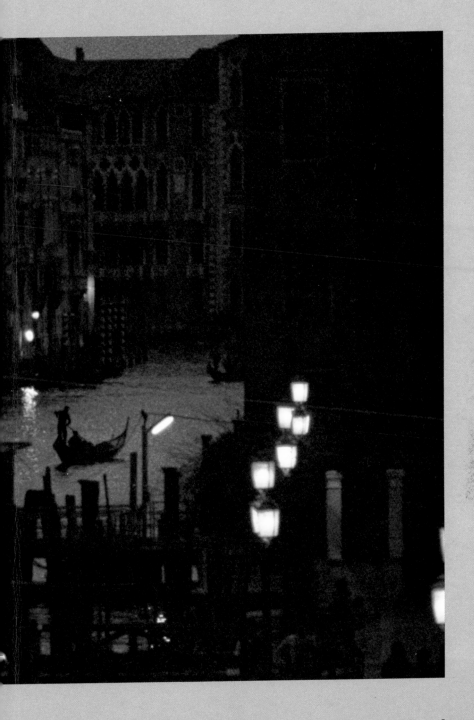

Kenya

Kashmir

Kenya
14

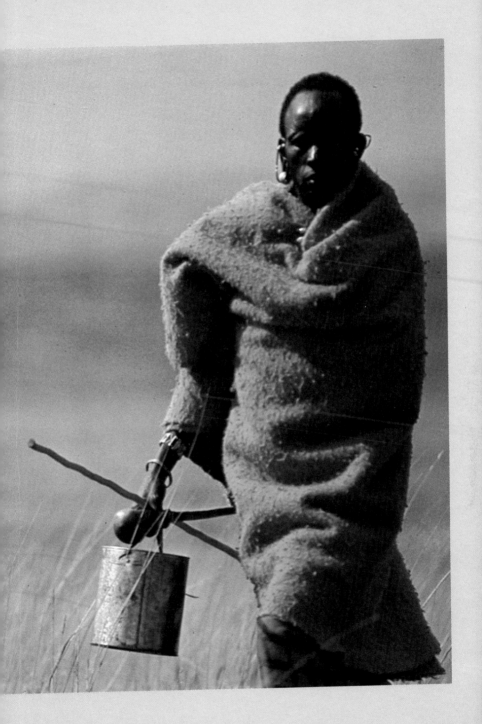

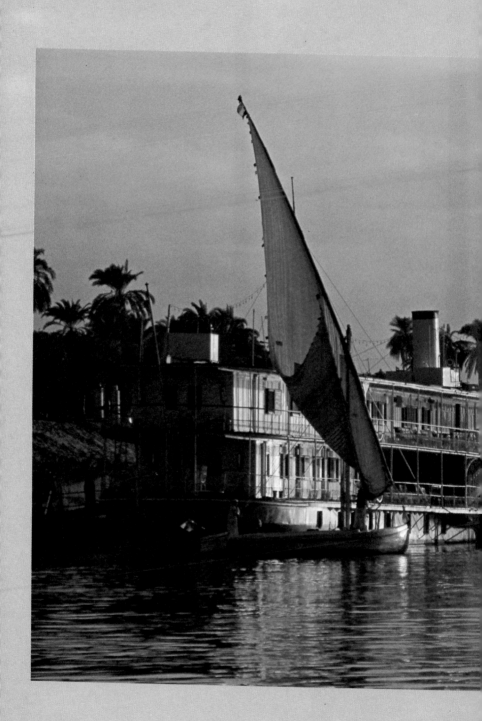

The Nile

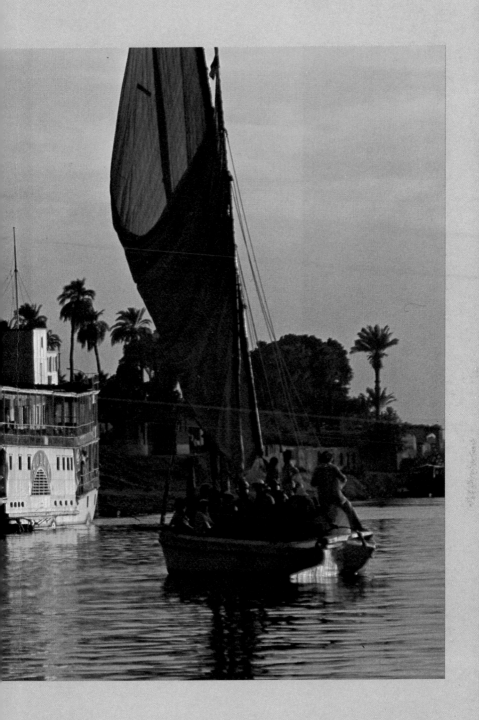

Introduction

As professional photographers we have travelled on assignments and holidays for the last twenty years. We have criticized each other's pictures and traded stories and tips. This book is an opportunity to pass on our experience to you. Most of the photographs for the book have been taken in the last four years. We have approached travel from two different positions: John goes on holiday with his family and has done so for several years, since his sons were six months old; their ages have never been a reason not to go abroad. He may occasionally have to sacrifice a potentially great picture because of a domestic crisis, but he is compensated by his children who are a rewarding subject in themselves. Julian travels mostly alone.

Every corner of the world is now accessible to anyone with the time and determination to get there. If you choose your holiday and trips carefully, travel can be very good value for money. It is surprising how far you can go for very little.

We have dealt with the reality of travel photography, not just the image presented by the glossy glamorous pictures you see in travel brochures. In the real world there is rain, wind, fog, sleet and snow, hotels with no view and paradise islands swarming with flies. We have experienced the lot, and been surprised when taking photographs for the book how many good pictures have come from the bad conditions. As professionals, it is reasonable that our clients should expect us to bring back pictures, not excuses or near misses. We have applied these standards to ourselves when producing pictures for the book.

A lot of photographic equipment is featured here, not as a catalogue but to help you choose kit that works best for your style of photography. As with travel itself, photographic equipment can offer amazingly good value as long as you know what you want. We hope to save your money, not spend it for you!

Our main aim is to equip you with the technical skill to take the sort of photographs you like. A good photographer has the ability to add that extra personal touch to a picture: to be able to put his 'mind's eye' on film. By the mind's eye we mean how we feel about what we see. A good picture illustrates this emotional response.

The developments in all areas of photographic technology in the last few years have been enormous. New generation 1000ASA films have appeared on the market, long focal length lenses with large maximum apertures and better colour rendition combine to make it possible to photograph in very low light conditions. Through-the-lens flash metering means you can handle flash photography with confidence and get consistently reliable results. Finally, all the major manufacturers have introduced 'programming', designed to guarantee you a picture.

But no matter what the camera brochures may claim you can't buy creativity, don't be seduced into thinking that the camera can do it all. Once you have a good command of the basic theory you can really appreciate the choices available. Which film, which lens and filter, and what time of the day shall I shoot the picture? The choice is as infinite as it is exciting. Photographers now have almost as much control over colour as the painter; you can control colour as if you were mixing it on a palette.

We have learnt a great deal about travel and photography while compiling the book. We hope that as a result of reading it your photography and travel will be more satisfying and rewarding. The one thing we have learnt is that there is no substitute for enthusiasm.

Julian Calder has travelled for 18 years and visited 63 countries. His distant cousin was Apsley Cherry-Garrard who wrote *The Worst Journey in the World* about Scott's expedition to the South Pole. Julian loves the active, outdoor life and the remote, tough spots of the world. As well as being absorbed by the technology of photography, he cannot separate photography from travel.

Julian has worked for Time-Life, *Illustrated London News* and many major magazines. He enjoys photographing the 'big event', such as royal weddings, state openings of Parliament, and diplomatic visits.

As a child Julian had ambitions to cross the Sahara Desert, trek in the Himalayas, go up the Amazon jungle and visit one of the Poles.

John Garrett was born in Melbourne and came to London in 1966. He worked first as a fashion and advertising photographer, but changed direction in 1971 when he went to Bangladesh to report on the India-Pakistan war. He has continued with reportage photography ever since.

He has done travel assignments for many companies and magazines including *Sunday Times*, Time-Life, *Paris Match*, *Sunday Express Magazine*, and *Stern*; and since 1982 he has also been directing films for television.

Cameras

The cameras illustrated here are all Nikons simply because we have both used Nikons for the whole length of our careers – forty-seven Nikons in fact.

This book is based solely on our own personal experience and it would be misleading if we illustrated cameras that we haven't lived with and got to know. However, all the leading manufacturers produce a similar range of equipment of a very high standard. What is important is that you should get used to your camera and feel comfortable with it.

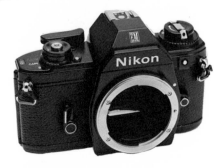

Nikon EM
A lightweight auto SLR camera which takes the full range of Nikon lenses. It has an exposure compensation button which increases exposure by 2 stops. You can bracket exposure by altering the ASA setting only. Excellent value. A good first SLR camera.

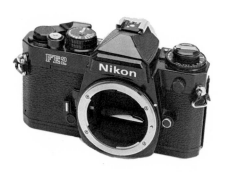

Nikon FE2
A well-tried travel camera – light and reliable. Shutter speed is up to a maximum 4000th sec and it will flash sync at 250th sec. Will work in aperture priority, auto or manual. The metering on auto is excellent. We strongly favour the shutter speed indicator needle of the FE2 over the LED readouts of most other modern SLRs, because you can see exactly what shutter speed the infinitely variable shutter is set at – the LED displays only 125th, 250th, etc., not the speeds in between. A lovely camera to hold, no matter what lens is attached.

Nikon FA

A leader in the high-tech race. The FA has both shutter and aperture priority exposure on auto, manual and program modes. When set on program the camera decides, no matter what the light conditions, on the correct exposure. The program has been fed with the information from thousands of pictures. You still have to tell the camera what you want for a special result, but otherwise it will work out a good average exposure in any situation.

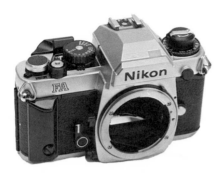

Nikon F3

A reliable, versatile working tool of the professional photographer. It has an aperture priority, auto exposure facility as well as manual. The finder can be removed – you have the choice of six – without affecting the metering. The F3 will accept an extraordinary range of accessories – there are very few jobs this camera can't tackle. The new F3/T made of titanium is even stronger than the standard F3. Both types have 80/20 centre weighted metering that takes time getting to know, especially if you have been used to the more common 60/40.

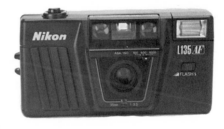

Nikon L135 AF

This is the cheaper of the two AF models made by Nikon. It has auto film loading, auto film wind, auto focusing, auto programmed exposure control, auto exposure flash control, auto film rewind. This is a great little camera of excellent quality. Another alternative for those times when you want to take shots but not the camera bag. Read the instruction sheet carefully. Takes very good flash pictures using 1000ASA film.

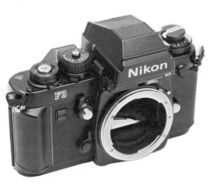

Cameras

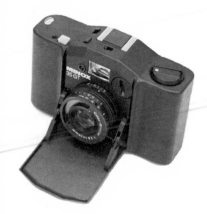

Minox 35 GT

A great little pocket camera, with auto exposure, aperture priority including a backlight compensation override. The 35mm f2.8 fixed lens is of the highest quality. It has a beautifully designed computer flash unit. The focus has to be judged and set manually, but at f8 in good light anything on a 35mm is sharp if you focus at 10 feet. John always carries one in the car. It's the camera he carries when he can't be bothered carrying a camera!

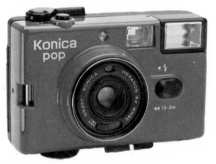

Konica Pop

A useful, well-made pocket camera. The quality is good, it has a built-in auto flash, the focus is manual. The Pop is extremely good value as that extra family camera on holidays – everybody can use it. Good to carry in the pocket or handbag. Memorize instruction manual.

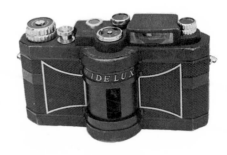

Widelux

A 35mm camera designed for landscapes and group portraits. The 26mm lens moves within its mount describing an arc of 140° during exposure, producing a sharp panoramic image occupying one and a half times the width of a normal 35mm frame. It has a range of only 3 shutter speeds – 15th sec, 125th sec and 250th sec. A pistol grip helps to stop the finger intruding into the picture. Julian is a fan of the Widelux because he favours the horizontal format.

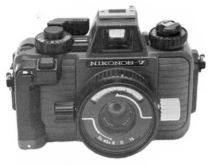

Nikonos V

One of the great travel cameras. We use it both as an underwater camera and, more important, as an adverse conditions camera for the beach, desert, rain and sea spray – all those situations that can destroy your normal equipment. A choice of auto or manual and with the Nikon 88–102 flashlight it offers auto TTL metering.

Lenses

Manufacturers' brochures beautifully illustrate the fact that lenses are now available covering all possible angles of view. But there is more to lens selection than just angle of view. Each lens has its own personality. This is why photographers have their favourite lenses, depending on the individual's own style and personality.

Any single lens may have many uses. However, it is difficult to know a lens's full potential without buying it first, which can be a very expensive exercise; so in this section, rather than angles of view, we have concentrated on the lenses' other properties. We ourselves have both made mistakes buying lenses that did not suit our style of photography. So we hope that this guide will help you to spend your money wisely.

The creative decision that a photographer makes when selecting a lens is based on its depth of focus potential

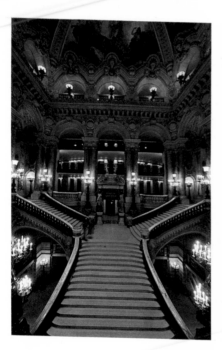

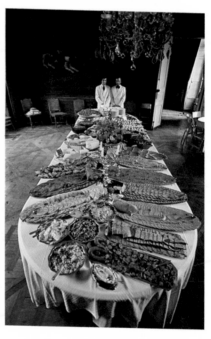

L'Opera
Full frame wide angle lens. It is very good for interiors and for pictures that have strong lines that need extreme treatment for effect. The distortion is only apparent at the edge of the frame where the subject is too close. The filters are built into the lens.
*15mm/Ekta EPY/tripod/***JC**

Buffet, Normandy
The extremely wide angle lens was used here to exaggerate the length of the table. I recorded how I felt about the fantastic French buffet, the mind's eye rather than the cold reality. The 'stretched' perspective made the waiters look even smaller in proportion to the plates of food than they already

were. The 18mm enabled me to look into the plates. I shot this quickly before the guests arrived.
*18mm/fil. 81A/Ekta ED200 @ 250ASA/exp. bracketed/ tripod/***JG**

and its ability to control perspective. Depth of field refers to thé area, foreground to background, that is in sharp focus. This is controlled by the aperture of the lens. The smaller the aperture the greater is the depth of focus. The wider the angle of the lens the greater is its ability to 'stretch' perspective. Conversely, the longer the focal length of the lens the greater its ability to foreshorten perspective.

In the last few years there has been a dramatic improvement in all types of lenses: they give better resolution, better colour rendition, they are lighter, have larger maximum apertures and focus closer. There is now a lens for almost any picture you may think of taking. It is an exciting time with all this new equipment we have at our disposal. But remember that fancy gear doesn't guarantee success, in fact it isn't absolutely necessary. People were taking great colour pictures thirty years ago, without the choice of lens we take for granted.

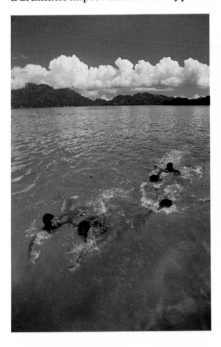

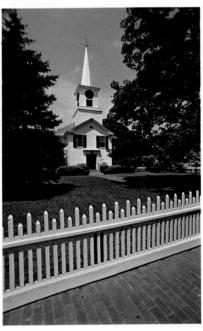

Swimmers, Seychelles
Wide angle lenses are used not just to 'get more in', but for their ability to increase the perspective for a graphic effect. This shot was taken with a 20mm lens to stretch the perspective and so that I could look over the top of the swimmers.
*20mm/fil.polar./ Ekta ER64 @ 80ASA/exp. auto −⅓/***JG**

Tisbury Church, Martha's Vineyard
The 24mm is a most useful lens. We consider the 35mm to be the normal lens and the 24mm to be the wide angle. Which wide angle to use is determined by how close or how high you can go to get everything in. By taking two steps backwards you change a 28mm into a 24mm. The 24mm only distorts if you are close to the subject, otherwise its perspective stretching qualities are used for graphic effect, as in this shot. The lines of the path and the fence all draw your eye to the church. An ideal lens for use in the city.
*24mm/Ekta EPR/exp. @ F16/ tripod/***JC**

Lenses

Berber barber, Morocco

Shot on 28mm lens to enable me to show the barber's tools in the foreground, the barber himself in the middle and the barber's patient customers in the background. The 28mm is the favourite lens for magazine photographers when shooting this kind of environmental portrait.
*28mm/fil. KR3/KD64 @ 80ASA/midday shade light/ exp. auto/***JG**

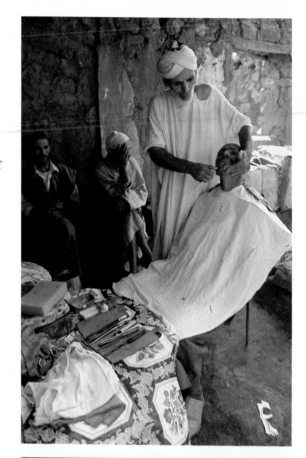

Gymkhana winner, England

I used a 35mm lens because I liked the proportions it gave me of horse to rider. The horse's head with the winner's rosette is large without distortion. Used as a 'normal' lens in place of 50mm because it makes you work closer, creating more interesting compositions.
*35mm/fil. A2/Ekta EN100 @ 125ASA/exp. auto −½ because of black area/***JG**

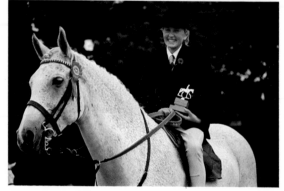

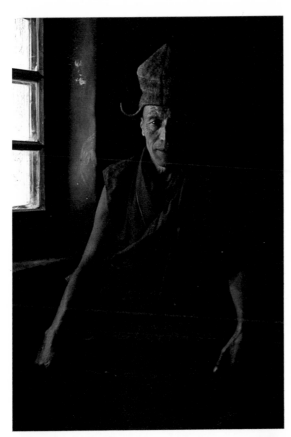

The Lama of Fuctal
The 50mm lens is considered to be the normal or standard lens, and it is usually the widest aperture lens of the manufacturer's range. The focal length of the lens is neither one thing nor the other, no wide angle or tele lens features. Sometimes this is exactly what you want – no optical influence in the picture, just content. But more often it's the wide aperture that is required when working in low light conditions. It is a good portrait lens if more than the head is to be included.
*50mm/KD64/windowlight/ exp. @ f2.8/tripod/*JC

Snowscape, Scotland
A focal length covered by most zooms, so why have a fixed focal length 85mm lens? Well, it has just the hint of a tele lens, the background is minutely compacted. You frame just beyond the immediate foreground, which often contains rubbish. The picture starts at the midground. A good portrait lens for those times when you don't want to be too close physically. The wide aperture of the lens makes it ideal for low light reportage pictures, it also stops down to f32. I use it this way when a subject has masses of detail and I want maximum sharpness and clarity.
*85mm/fil. KR1.5/KD64/mid- morning winter light/exp. @ f22/tripod/*JC

Lenses

Football training, Florence

Late afternoon, half daylight, half floodlight. The large aperture (fast) 135mm lens allowed me to concentrate on the front figure, leaving the two background figures out of focus. We are looking at one man but are aware that he is training in a group. This focal length is covered by zoom lenses but the larger aperture made the picture possible.

135mm/no fil. – floodlight had a strong warming effect/Fuji 400 @ 800ASA pushed 1 stop in processing/exp. 60th @ f2/JG

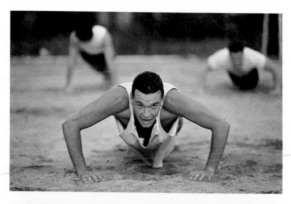

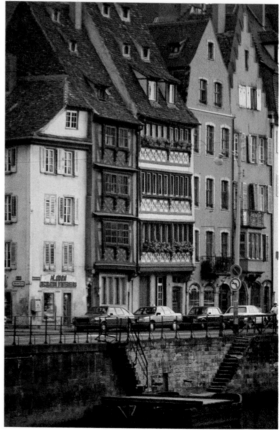

Strasbourg

I use the 180mm lens for the same reasons as the 85mm, for its range of apertures. When there is quite a distance between the foreground and the background that has to be sharp, it is used stopped down. Here it was used wide open because it was almost dark and, rather than use a 35mm lens closer up, I went further away to employ the tele lens properties, that is the foreshortening of perspective, which has made the building appear narrower and even closer!

180mm/fil. KR1.5/3M 1000/exp. 60th @ f2.8/ handheld, resting on bridge handrail/JC

28

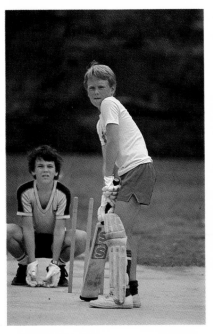

Young cricketers, Sydney

A 300mm lens was used here so that I was not in the way of the ball when it was bowled and the boys could concentrate on their game. The narrow angle of view of the 300mm cut out rubbish that was in the background. At 300mm you first start seeing a real telephoto effect. It is an ideal travel lens – compact, it can be handheld at anything over 250th of a sec. With the addition of a teleconverter it becomes a serious telephoto lens. It is the most often used lens of wildlife photographers.
*300mm/fil. A2/Ekta ED200 @ 250ASA/exp. auto @ 500th/**JG***
© Time-Life Books 1985.

Rio de Janeiro

The world begins to look very different through a 400mm lens, the foreshortening of perspective is visually exciting. This picture demonstrates the obvious use, in the way it has compacted the sweep of the road. It is also a fine headshot lens, very flattering because the features of the face are on one plane – no big noses or bumps, just the outline of the jaw with eyes, nose and mouth. It can be handheld but it soon gets heavy; better to use a tripod and a motor drive for maximum effect. These days with so much security at public and sporting events you have to use a 400mm or more to get tight pictures on the field of play. The wide aperture gives you control of the background – it can either be sharp or thrown out of focus into soft shapes and colours.
*400mm/fil. A2/Ekta EPD/late afternoon, January/exp. @ f11/tripod/**JC***

Lenses

Lovers, Kenya

The 500mm mirror lens was used purely for a romantic effect. The long lens has 'pulled' the sunset-lit water up behind the couple like a pink backdrop. With a short lens there would have been the distraction of boats and trees, etc. The mirror lenses are very compact and lightweight. They turn out-of-focus bright highlights into round doughnut shapes. They are good value for money – the disadvantage is that they have a smaller aperture (which is fixed) than conventional tele lenses.

500mm mirror/fil. 81C stuck on back of lens with Blu-tack/ Ekta ED200 @ 250ASA/exp. auto −¼/tripod/ **JG**

Nyhavn, Copenhagen

The 600mm is a big heavy lens used for sports, animals and public events – for those occasions when you have to get in close. It is too big to carry around as a general lens. For travel photography it's either in the car or left in the hotel and only used when you have planned a specific picture for it.

Landscape pictures in low light or bad conditions have always been difficult and risky with long lenses. The wide aperture has made it possible to get really good results in awkward conditions.

The clarity of the edge-detail and the squashed up effect, both special properties of the lens, have made this picture.

600mm/KD64/exp. auto, bracketed with compensation dial @ f11/tripod/ **JC**

30

Below are two examples of 'lensing'. We have used the particular properties of a lens to make a picture. Knowing a lens's visual potential and then applying it will give your photography indiduality. One of the satisfactions of modern photography is being able to use lens technology to enhance a picture.

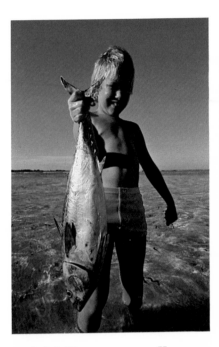

Ben's fish, Kenya
Ben was justly proud of his catch, but we decided to impress the school friends by making it appear even bigger. With the fish held out close to the camera the 24mm lens was able to make the fish almost as big as Ben. His head is near the edge of the frame and is becoming distorted.
*24mm/fil. 81A/Ekta ER64 @ 80ASA/exp. auto/**JG***

Hawes
Hawes in Yorkshire appears to be nestling at the foot of the hills – but the camera, or rather the lens, has lied. This is a situation where a lens has created a picture. In order to isolate the church, the focal point of the village, I had to go up the other side of the valley. The camera is about three miles from the village and the hills are a mile beyond that. The properties of the tele lens have made it possible to come in from a long way off, and to foreshorten the perspective, i.e. squash up the background.
*600mm × 1.4 teleconverter/fil. 81A/KD64/afternoon light/ tripod with guy ropes/**JC***

Zoom lenses

The worldwide interest in photography has created a demand for good zoom lenses. This family of lenses is perfect for the traveller and, contrary to popular prejudice, we know from our experience that they are not inferior to fixed focal length lenses. They have the advantage of being several lenses in one, which cuts down on bulk and expense.

As a tourist you are often forced to shoot from a fixed position, and a zoom allows you more framing possibilities. You save a lot of time by not having to change lenses. With a zoom lens coupled with a winder, and the exposure on auto, you have the capability to take pictures that you would have missed with a fixed focal length lens. When we go out 'walking the streets', rather than carry large aperture lenses to cope with difficult light conditions, we carry zoom lenses and several rolls of fast film.

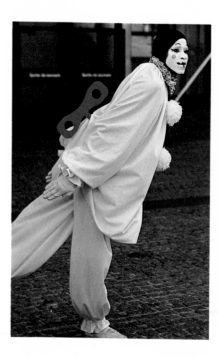

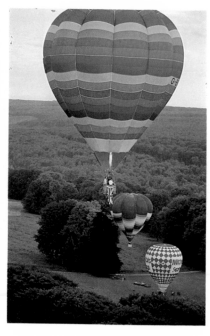

Clown, Paris
One of the advantages of a zoom lens is that it allows you to 'hold' a moving subject in the frame – so it appears the same size even if it is receding. Without moving yourself you can frame your picture perfectly, and choose just the right focal length lens for the picture.
*35–105mm zoom/fil. 81A/ Fuji 100D/exp. auto/***JC**

Ballooning, Normandy
I shot this picture from another hot air balloon – the zoom is the perfect lens when you have no control over your own position.
*80–200mm zoom @ 120mm/fil. 81A/Ekta ER6 @ 80ASA/exp. auto/***JG**

La Défense, Paris

In order to get all of the building in with an ordinary 28mm lens, the camera has to be pointed upwards, making the building appear to lean over backwards. The perspective control lens corrects the lean. I have found the 28mm more versatile and better for the city than the 35mm PC.

*28PC/KD25/tripod/spirit level on hot shoe/***JC**

Hot lips

The macro lenses allow you to take close-up photographs without any additional attachments. They are inherently very sharp, and can also be used as normal lenses. You begin to see the world differently. The girl's lips were shot on a 105mm macro.

*105mm macro/fil. KR3/Ekta ER64 @ 80ASA/exp. reading by flash meter/tripod/***JG**

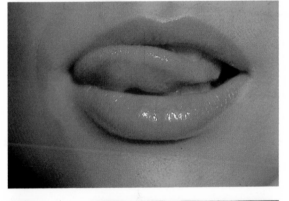

Knights, Florence

A teleconverter is very useful for the travelling photographer. It can double the focal length of the lens that it is coupled to. It is small and saves you carrying two or three extra long, heavy lenses. The quality is now very good, the disadvantage is the loss of usually 2 stops, which can be a problem. But it does give you a greater range of possibilities. I carry a ×1.4 which only loses 1 stop and a ×2 which doubles focal length with the loss of 1 stop.

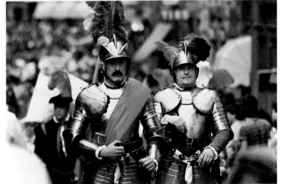

This picture with 400 converted to 800mm gave me the chance to shoot long before the parade reached me.

*400mm ×2 teleconverter/no fil./Ekta ER400 @ 800ASA/ exp. auto, pushed ½ stop in processing/tripod/***JG**

Exposure

The most important decision we make as photographers is that of exposure. It determines the whole feel of the picture. A simple guide to help you make this creative decision is to decide what the main image is then expose for it, remembering how the film you are using will react in the prevailing light conditions. When the principal feature dominates the composition metering is not a problem. It is when it is only a small part of the whole or it is in difficult light that you need to pay careful attention in deciding your exposure.

From reading your camera's manual you will be aware of what sort of metering your camera has. It is helpful to be familiar with this because you will know when to trust it and when to override it. With the new 'programming' systems, you set a dial and then the camera takes over and does everything, not only regulating the aperture and shutter but deciding what the main feature is and then exposing accordingly. This 'optimum' light exposure guarantees a photograph. But the camera can't make a creative decision, you have to tell it what to expose for. This may mean using a hand meter for incident light readings or a spot meter.

With automatic exposure (auto in our captions) you set the aperture, and the camera adjusts the shutter to the exposure value of what is in the viewfinder. This is known as aperture priority. Shutter priority is similar; you set the shutter and the camera adjusts the aperture. Both systems are equally good for travel photography because you can override them by rating the film differently or by using the exposure compensation dial.

The camera meter determines the

Fishing boats, Crete
This picture is what we consider an average exposure for an average picture. The picture has good saturation of colours at both ends of the spectrum and a clean neutral white. The shot is about ¼–⅓ stop darker than a film manufacturer would recommend. We always uprate film speeds slightly to produce more saturated (stronger) colours.
105mm/fil. 81A/Ekta ER64 @ 80ASA/late afternoon sun/JG

exposure by reading from a sensitive central weighted area filling either 20% or 40% of the viewfinder. 80%/20% weighting is too specific for travel photography – a small bright area, if it is in the centre of the shot, will influence the overall reading – causing underexposure; and the converse is also true (see the Guards picture on page 41). 60/40 weighting is much safer.

Modern microelectronics have made exposure less of a problem, but nature still has the upper hand. A sound knowledge of the basis of photography is essential if you want to master and control light. The pictures on the following pages show different exposure problems successfully solved. We still make mistakes. Even ½ a stop less exposure could have turned an ordinary photograph into a really good picture. The creative decision is that

1 Automatic multi-pattern metering reads each segment, then decides on an optimum overall exposure.
2 60%–40% centre weighting, the reading is biased towards the central area.
3 Spot reading, the exposure is taken from the centre.

critical. For consistently reliable exposure use the technology, but if the shot matters, bracket – it's still the only insurance for taking the picture you want.

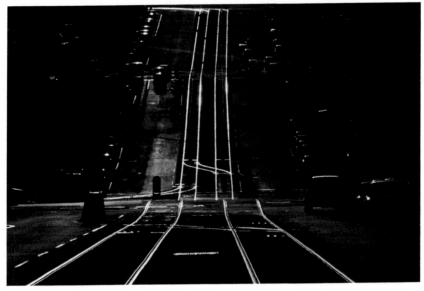

Tramlines, Melbourne
There is no such thing as correct exposure. It depends on the result you are looking for. This shot is exposed for the brightly

lit tramlines, 3 stops under the general meter reading. 'Correct' exposure would have produced an ordinary shot of a city street with

tramlines.
*300mm ×1.4 teleconverter/ Ekta ED200 @ 250ASA/exp. 250th @ f22/tripod/***JG**

Exposure

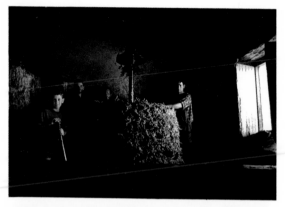

Grape crushers, Portugal
Another difficult situation for an auto camera because it wants to expose for the large dark areas and this would overexpose the faces. I took a reading of the boy's face with my hand meter and set the camera manually.
24mm/fil. 81A/KD64 @ 80ASA/exp. 8th @ f5.6/tripod/ **JG**

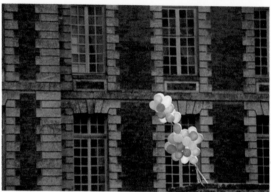

Balloons, Normandy
The reverse problem to the surfer (this time correctly solved) – a small brightly-lit area against a dark background. The auto camera will try to expose for the wall, leaving the balloons overexposed. I underexposed this shot 1⅓ stops on auto setting.
80–200mm zoom @ 150mm/fil. A2/Ekta ER64 @ 80ASA/exp. auto −1⅓ stops/ **JG**

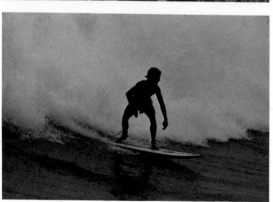

Surf rider, Sydney
This exposure was a mistake. Shot on auto, the camera has exposed for the very bright foam of the wave with detail, throwing the surfer into silhouette, which I didn't want. I should have taken general readings off my own hand and set the camera manually or taken an incident reading with my exposure meter. Snow and bright beaches will have the same effect.
400mm/Ekta ED200 @ 250ASA/exp. auto/tripod/ **JG**

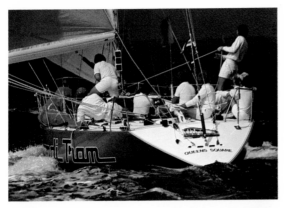

Yachting

The white sailors and yacht against the dark sky would have confused the automatic camera meter. It would have given an average exposure, resulting in an average picture. Exposing for the highlights has held all the detail in the sailors – the main feature – and made the sky darker and more dramatic.

*180mm/fil. KR1.5 (1A)/Ekta EPD/exp. @ 500th/*JC

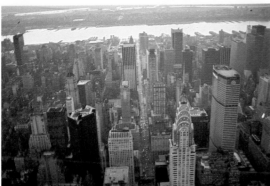

New York

The camera meter has been set on auto and this has correctly exposed for the skyscrapers, but the sunset is way over. The reading should have been taken from the sky. The overall picture would have been darker but correct. Be careful when using wide angle lenses on auto.

*24mm/KD64/exp. auto @ 250th/helicopter/*JC

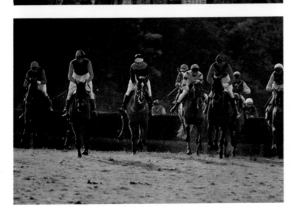

Point-to-point

Perfect conditions for automatic exposure – even frontlight. The backlight is stronger but occupies too small an area of the viewfinder to affect the reading. Set on auto because there is a lot of action going on. Remember to concentrate on the main image, rather than any other information displayed in the viewfinder.

*400mm/fil. A2/Ekta EPR64/ exp. auto @ 500th/motor drive/tripod/*JC

Exposure

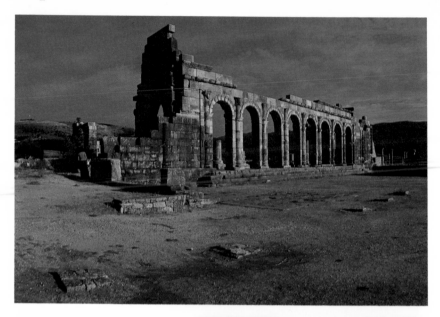

Volubilis, Morocco
The reason for deliberately underexposing this shot was to make the Roman stone arches the main feature, reducing everything else to black. Done by not adjusting the exposure after adding a polaroid filter.
*28mm/fil. 81B + Polar./KD25/ exp. manual + bracketing/ tripod/***JC**

White lady, Cannes
This very theatrical lady was sitting at a table in front of the famous Carlton Hotel during film festival week. I overexposed the shot 1 stop as an experiment. I think the washed-out look suits her well. Once again, correct exposure depends on what you are looking for, and at.
*35–105mm zoom @ 80mm/no fil./Ekta ER64 @ 80ASA/exp. auto + 1 stop/***JG**

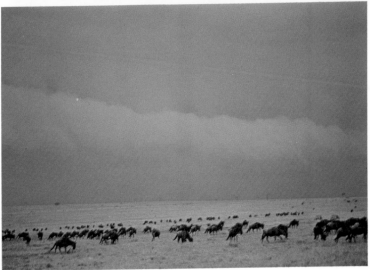

Tivoli, Copenhagen
The ballerina risks being overexposed, as she is in white and lit! I took an average reading for the central foreground.
*180mm/fil. KR1.5/3M 640T/spot meter reading/***JC**

Wildebeest migration, Tanzania
For this shot I took the reading by pointing the camera at the grass and using the exposure lock. The shot would have been ½ stop lighter if taken straight on auto, the storm clouds would have been lighter and less dramatic, incorrect in fact.
*80–200mm zoom @ 200mm/fil. 81A/Ekta ER64 @ 80ASA/exp. auto +½ stop/***JG**

Exposure

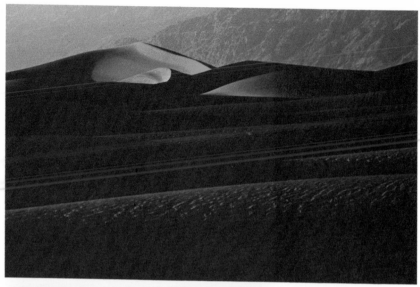

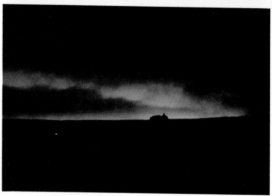

Death Valley, California
When shooting static subjects on a tripod you often get lovely surprises if you bracket the exposures. Here I exposed for the highlights, 1½ stops under the camera's reading.
*80–200mm zoom @ 180mm/fil. A12/Ekta ED200 @ 250ASA/exp. auto −1½ stops/tripod/***JG**

Dales
Exposed for the highlight in the stormy sky, making it seem more threatening, and the house a safe sanctuary! The wind was so strong I had to use the fastest shutter the light would allow. (A different version of the same picture appears on page 49 but shot from inside the car, safe from the wind.)
*135mm/fil. KR3/KD64/60th @ f2.8/tripod/***JC**

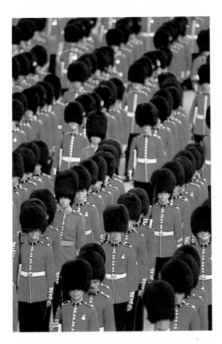

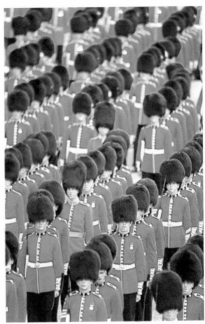

Trooping the Colour
The camera meter – on the right ASA setting in even light – has given the correct exposure with the information it has received, but it is the wrong exposure for the picture.

Manually adjusted by 1 stop – the bearskins are now black and they have faces! This is an extreme example of an exposure problem, a **small face in a dark background.**
*600mm/Ekta EN100/1 exp. auto 2 exp. auto −1 stop/ tripod/***JC**

Jill, England
The dark shot of Jill was exposed on auto and the lighter one was overridden by 1½ stops.

Backlight is pouring into the camera meter and giving a false reading on the face – which is fine if you want a silhouette.

Most auto cameras have a backlight override.
*135mm/fil. KR3/Ekta ER64 @ 80ASA/exp. auto + 1½ stops/***JG**

Bracketing

When the camera meter tells you what it thinks is the right exposure for a picture, this is no guarantee that it's the perfect reading for the picture you have in your mind's eye. Therefore, it's often necessary to override the meter, or bracket, and choose your own exposure. You can't bracket on every subject you want to shoot – in reportage, for instance, when you only have one chance, you simply have to shoot the whole roll on the meter, then clip test and adjust the exposure in the processing. Familiarity with your camera, light conditions and film will reduce your reliance on bracketing. For pictures with extreme contrast like the Melbourne tram lines (page 35) you may find it necessary to override the general meter reading by as much as 3 stops. It is more usual to do it in degrees, ½ stop over and then in 3 ½ stops under. You should always bracket when using more than one filter, especially a grad., a polarizer or both. When shooting Kodachrome, it's best to bracket because you can't adjust the processing. When depth of field is critical and you can't change the aperture, bracket by changing the shutter speeds. If the camera is set on auto use the exposure compensation dial which is adjustable by ½ and ⅓ stops. Finally, if you use a manual camera or one that doesn't have an exposure compensation dial: bracket by adjusting the ASA dial. For example if you are using 200ASA film, put the dial on 400ASA to give a 1 stop underexposure, or 100ASA to give a 1 stop overexposure. For exposures of 5 minutes or more bracket in whole

Cephalonia Island, midday, July
2 stops underexposed. Most people would consider this too dark. This is not the right subject but there are many pictures that work if they are 2 stops underexposed.

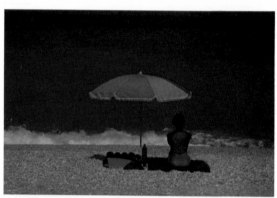

1 stop underexposed. Still a good exposure, solid colour, detail in all the highlights. It doesn't look as hot as it was.

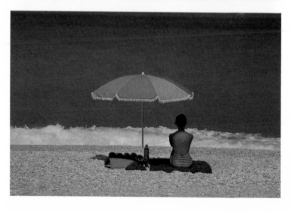

stops because the difference in ½ stops is barely perceptible.

The manufacturers reckon that programming should eliminate the necessity of bracketing. This is probably true with negative film, when a picture can be rescued in the printing stage, but not true with transparency. You are the one who is taking the pictures, so don't let yourself be ruled by the manufacturer's idea of exposure: if in doubt bracket.

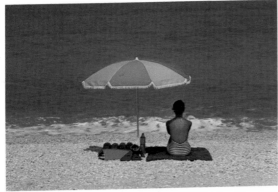

½ stop underexposed. This is what we consider to be a good exposure. There is good colour saturation, the reds, oranges and blues are strong. The model has a good suntan and it looks hot. A definite difference between highlight and shadow areas.

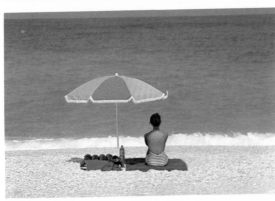

This is what the camera meter considered to be the right exposure. It has based its exposure decision on the shadowed area of the umbrella and the white beach. The exposure is technically perfect, but not right for the picture.

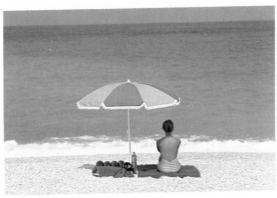

½ stop overexposed. Too light, the umbrella is not doing any shading – the tan is too pale but you can read all the detail under the umbrella.

From this example, you can see why exposure is so critical and why you have to decide what is the main feature in the picture and expose for it accordingly.
*135mm/no fil./KD64/*JC

Aperture

An understanding of the relationship between the shutter and the aperture and its creative implications is fundamental to taking consistently good photographs. The ability to look at a subject and know what combination to use for a particular result soon becomes second nature. The instamatic type of camera chooses an average combination of shutter and aperture, producing an average picture. More sophisticated cameras allow you to choose from the whole range of combinations. A picture can be sharp from a few inches from the camera to infinity when the aperture is stopped down, or can focus on an object and leave the rest of the picture unsharp when the aperture is wide open. With every alteration of the aperture there must be a corresponding alteration to the shutter speed in order to maintain the same exposure value.

These pictures demonstrate the choice a photographer has when deciding which combination of shutter and aperture to use. Shot in bright midday light, the same reading as the meter illustrated, the average exposure would be 250th @ f5.6.

Of all the photographic elements that combine to create a picture, the controlled use of the aperture is the least understood. It is a simple technique that is very effective and often 'makes' a picture.

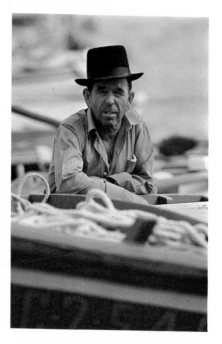

1 15th @ f22. Sharp from foreground to background, but the background is a mess; people in the fisherman's hat and a fishing rod coming out of his ear.

2 1000th @ f2.8. Only the fisherman is sharp, the intrusive background rubbish has gone. His face in both pictures looks the same, because the volume of light was the same.

Remember if you open up (aperture) speed up (shutter); if you slow down – stop down.

44

When an exposure meter reading is taken in any given light conditions, the meter indicates a range of shutter and aperture combinations, all of which will achieve the correct exposure. As you can see from the illustration, 4000th of a second @ f1.4 has the same exposure value as 15th of a second @ f22. The combination you use will be determined by whether your picture requires an aperture priority or a shutter priority.

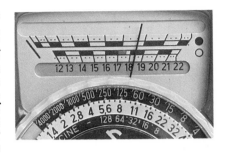

To avoid unsharp pictures caused by camera shake, here is a guide to the slowest shutter speed for handholding various lenses.

24/28/35mm – 30th sec
50/80/105mm – 60th sec
135mm + zooms – 125th
180/200/300mm – 250th sec
400/500mm – 500th sec

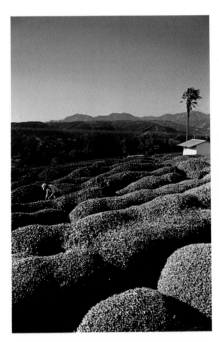

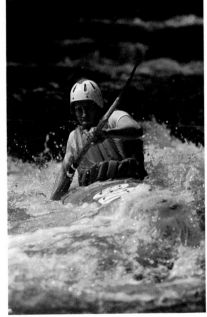

Tea fields, Japan
This shot needed to be sharp from foreground to infinity. Stopped down to f11, a blue grad. darkened the top half of the picture. *28mm/fil. ½-stop blue grad./* *ER64 @ 80ASA/exp. auto −½ @ f11/***JG**

Canoe
In order to hold the canoeist off the background and freeze the water I had to use the fastest combination I could. The sharpness of his face and the wall of water in front of him creates the drama of the picture. *300mm/EPR64/exp. 2000th @ f2.8/tripod/***JC**

Aperture

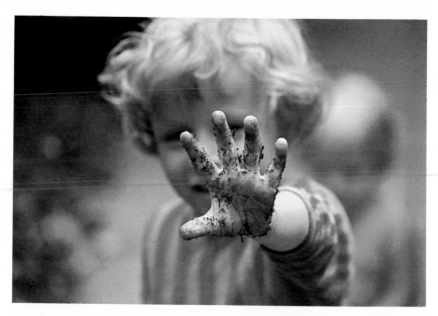

Dirty hand, USA
Shot wide open on 35–105mm zoom @ 60mm. The narrow depth of field concentrates your eye on the dirty hand but still enables you to see that it belongs to a little boy.
*35-105mm zoom/fil. A2/Ekta EN100 @ 125ASA/ exp. auto/***JG**

Boy fishing, Seychelles
I wanted the silhouette of the little boy to stand out clear and sharp from the background, so I used my 300mm lens @ f4.5. At, say, f16 the boy and his net would have merged with the sea.
*300mm/fil. KR3/KD64 @ 80ASA/exp. auto/ tripod/***JG**

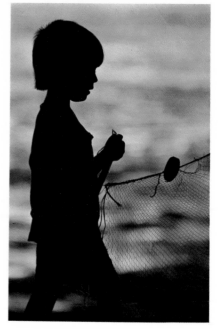

Girl and flowers, UK
The narrow depth of field of the 400mm lens @ f3.5 has turned the foreground roses into soft feminine pink shapes that don't distract but draw the eye to the girl's face.
*400mm/fil. A2/Ekta ED200 @ 250ASA/exp. auto/***JG**

Nyhavn, Copenhagen
The first of the ships is 250 metres from the camera and the five ships in the picture cover another 100 metres. The long lens has foreshortened the perspective. For the full effect everything must be sharp through the picture. So the smallest aperture practical was used.
*600mm/fil. A2/late sunlight/ exp. 30th @ f16/tripod/***JC**

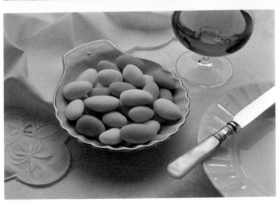

Almonds
The closer the camera is to a subject the less depth of focus there is. In a still life picture when you want it sharp throughout, focus on something ⅓ of the way into the picture and stop right down. This will bring the remaining ⅔ into sharp focus.
*55mm macro/fil. 85B/KD64/ exp. @ f16/tripod/***JC**

Shutter

The shutter priority is dictated by a need to control movement, whether it's the freezing of a splash of water @ 1000th or 2000th sec or using a 30th sec or longer to allow the water to blur into a flowing stream. With every alteration of shutter speed there must be a corresponding alteration to the aperture in order to maintain the same exposure value.

A fast shutter speed should not only be used to freeze a moving subject but also if you are moving and the subject is still. For instance, from a light aircraft or two-bladed helicopter shoot at 1000th sec, a three-bladed helicopter, trains and cars, 500th sec. But remember when you are moving along there is very little time to compose a picture – don't wait to see if it gets any better, just shoot anyway. Like the aperture, the understanding of the shutter often makes a picture and will freeze a moment of time for posterity.

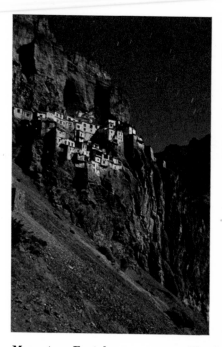

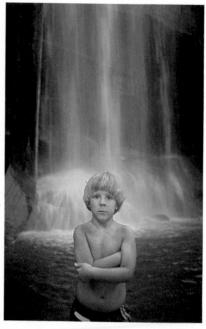

Monastery, Fuctal
The Buddhist monastery at Fuctal in the Zanskar mountains. The light of the full moon lit up the ramshackle buildings clinging to the mountain-side. I took the exposure reading off a piece of white paper. The shutter was locked open by using the cable release. The streaks in the sky are the movement of stars during the 15-minute exposure.
*35mm/no fil./KD64/exp. 15 mins @ F8/***JC**

Mathew and waterfall
The waterfall in the background has blurred into a milky white flow by using a 30th sec. If the exposure had been made at, say, a 500th sec the waterfall would not have been visible against the black rocks.
*80–200mm zoom/fil. A2/Ekta ED200 @ 250ASA/exp. 30th @ f4.5/camera steadied on tree/***JG**

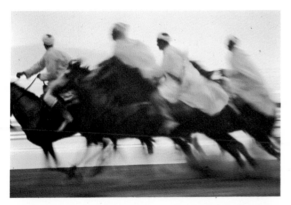

Fantasia, Morocco

The horsemen have been allowed to blur across the film by panning on a 15th sec. I was after a feeling of dream movement.

*300mm/no fil./Ekta EL400 @ 500ASA/exp. 15th @ f8/***JG**

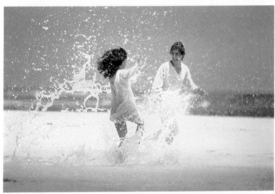

The big splash, Kenya

This shot is 'made' by the use of a very fast shutter speed. A 2000th sec has frozen the splash into a pattern not apparent to the naked eye.

*300mm/Ekta ER64 @ 80ASA/exp. 2000th @ f5.6/***JG**

House on the hills

A very windy night: the clouds were scurrying across the sky. From the protection of the car I could use a long exposure without getting camera shake. The moving clouds have given the sky a milky look. It is imperative to keep the camera rock steady during long exposure.

*180mm/KD64/exp. 2 sec @ f16/tripod – one leg in car, two on road/***JC**

Shutter

Cricket, Lords
The bowling action of Ian Botham at 1000th of a second. The fast shutter speed has clarified a movement that is difficult to see with the eye. I shot this picture from my seat in the stand.
*500mm/Ekta EPD200 @ 250ASA/exp. 1000th @ f8/ tripod/*JG

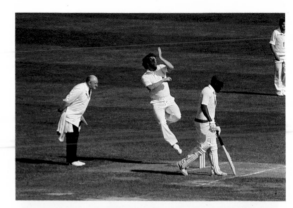

Racing
You don't need a particularly fast shutter speed to freeze a subject that is coming straight at you, especially if you use a long lens. They don't appear to be travelling too fast. It is not until they flash by (across the frame) that you need a fast shutter.
*Exp. 250th @ f5.6/tripod/*JC

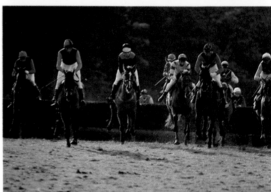

British Grand Prix
When photographing a very fast moving subject it is easier to do it from a distance and then fill the frame by using a long lens. I couldn't do this on the fast straight at Silverstone. The cars reach 180 mph here, being so close the speed was astonishing. So I had to use the fastest shutter speed to freeze the car.
*85mm/KD64 @ 80ASA/exp. 2000th @ f4/5.6/*JC

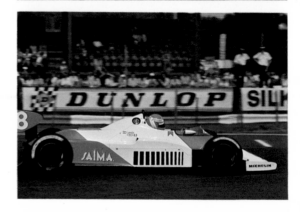

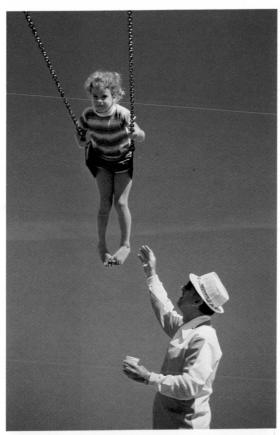

Swing, Seattle

Because I caught this little girl at the peak of her swing, and because she is moving almost straight at the camera I was able to freeze her at 125th sec.
*80–200mm zoom/fil. polar./ Ekta ER64 @ 80ASA/exp. 125th @ f11/***JG**

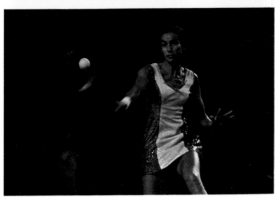

Tennis

The racket of Virginia Wade's forehand return is blurred but the ball is frozen. It is that split second when the ball is not going anywhere. With any game that is repetitive, you can start to anticipate the pace. Shoot single frames using the motor to wind on so the camera never leaves your eye.
*300mm/no fil./Ekta EPT @ 300ASA/exp. 250th @ f2.8/ unipod/***JC**

Shutter

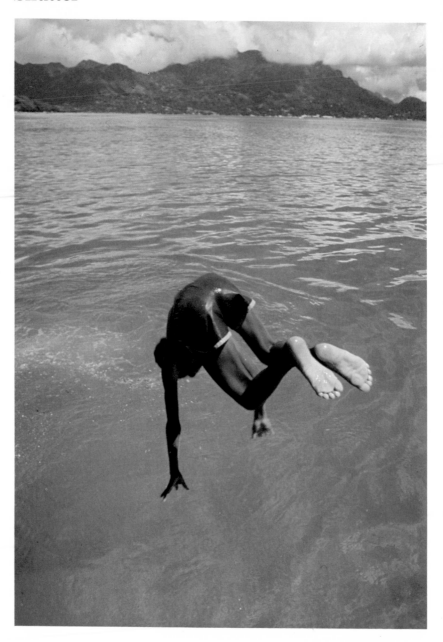

Suspended boy
Between a 250th and a 500th sec was fast enough to freeze the boy diving away from me. If he had been moving across the camera I would have needed a 1000th sec.

*20mm/fil. 81A/Ekta 64 @ 80ASA/exp. auto/***JG**

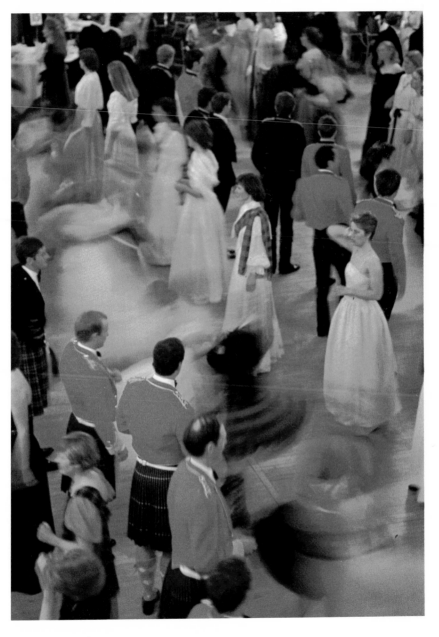

Reels
At a Scottish dance I used
a slowish shutter speed so
the reels would appear as
swirls of movement.
*35mm/Ekta EPY/exp. ¹/₄ @
f11/tripod/**JC***

Film

Film manufacturers have made considerable technical advances during the last couple of years. Kodak, who until recently dominated the film manufacturing business, are now experiencing intense competition from Fuji, 3M, Agfa, Ilford and others.

Photographers have benefited greatly because now there is a film for every occasion and every picture requirement. We can now take colour pictures where at one time only black and white would have been thought possible. This is due to the introduction of new 1000ASA plus film, which is very sensitive to light. The combination of these new fast films and the new generation of large aperture lenses can produce remarkably good results in very low light conditions. Besides an increase in speed, there has been an improvement in tonal quality, better colour rendition in the primary colours, and a new grain structure that gives greater sharpness.

All the pictures in the book were taken on transparency film and the box ends illustrated are all for transparency film. The reason for this is that only with transparency film can you have creative control of your final result. The picture is created in the camera rather than in the darkroom. With negative film the final result is in the hands of the printer, or more often than not, the printing machine.

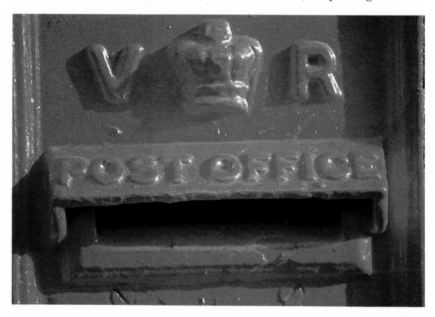

Post box
The post box had just been painted for the thousandth time! In the direct sunlight every detail could be picked out. As the post box wasn't going to move, I was able to use the tripod, a slow shutter speed and a small aperture ensuring maximum sharpness. All the right conditions for choosing Kodachrome 25, a fine film for this kind of picture.
*200mm micro/fil. 81A/KD25/ exp. @ f22/tripod/***JC**

If we do need prints we always have them made from transparencies because then the printer has the original as a guide. Very few people have the experience and skill required to judge a colour negative and to know what the finished print should look like. You may find a skilled printer who is capable of creating marvellous results but a machine has limited 'taste'! In the end it is the subjective decision of the photographer that is important.

By shooting transparency film you can judge immediately what is right and what is wrong with your pictures and how they could be better. We have illustrated 25 types of film and each has a special quality. Some are more suited to certain subjects and light conditions than others. This wide variety is exciting and makes your choice critical because the quality of certain brands and ASA ratings can enhance your pictures. Knowing the right film for a particular picture is an important part of modern photography.

We feel that camera manufacturers design the metering system to shoot colour negative. Following your meter will give you a good negative but on the same ASA setting it will overexpose transparency. We therefore always uprate our film to get transparencies with stronger colour, better

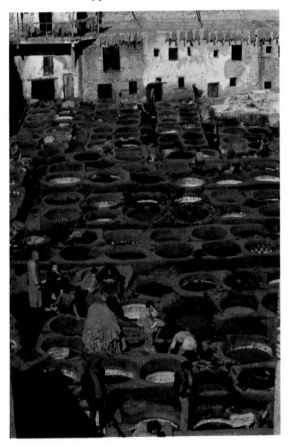

Leather dyeing pits, Fez
The same hard light as the post box but this time from right behind the camera. There is detail, people and subtle colour in the shot, all of which needed to be seen. Kodachrome 64 was the natural choice, because it is faster than Kodachrome 25. I use it when there are people or other moving things in the picture. All Kodachromes work especially well in bright clean light.
*85mm/fil. KR1.5/KD64/ morning light/*JC

Film

saturation. This is what we rate our film at – but process normally:

64ASA to	80ASA
100ASA to	125ASA
160ASA to	200ASA
200ASA to	300ASA
400ASA to	500ASA
640ASA to	800ASA
1000ASA to	1200ASA

The exceptions are the new so-called 'push films' made by Fuji, Agfa and Kodak.

If you take your photography seriously, entrust your film to a commercial or professional processing lab. It's their job to take care of film and they are used to professional photographers being really fastidious.

Learn the terminology. Get to know the lab technician: he can be a valuable teacher, and he will respond to your enthusiasm.

We think it's better to have a sharp, grainy picture than a fine-grained one which is unsharp. Very few blurred pictures get published. If there is not enough light for the film you are using, uprate considerably, i.e. 400ASA to 1200ASA; an increase of 1½ stops. Then process accordingly, pushed 1½ stops. Remember to mark the roll, and never change ASA halfway through the film.

Pushing film results in an increase in the size of the grain and an increase in the contrast. For best results only push 200ASA film and above and don't

Sunchairs, Florida
Water and sky – the conditions that a slow to medium speed E6 film handles well. The shot is polarized. Ektachrome and Fuji are best for blues and polarize better than Kodachrome. Shot midday; too hot even for the sunworshippers.
80–200mm zoom @ 100mm/fil. polar./Ekta ER64 @ 80ASA/exp. auto/JG

underrate i.e. lower the ASA. In theory this should work but in practice it's not reliable. If you have any doubts about how the film should be processed have it clip tested: the first 4/5 frames are processed and if any adjustments are needed the rest of the film can be processed accordingly – good labs can process to a ¼ of a stop!

When making very long exposures in low light often find that your meter reading produces an underexposed result. This is due to reciprocity failure, when the reciprocal relationship between exposure and light intensity no longer applies. There are no rules to give you, unfortunately – just remember when exposing at say 10 secs, its worth shooting a frame at 1 minute exposure just to make sure. If you discover that you have seriously overexposed on E6 film, don't panic! All is not lost. You can save the film by processing it as a colour negative and making prints.

Father and son, Spain
Slow E6 film also excels with skin tones. It's used here with a warming filter. Midday light in the shade of an umbrella.
*35mm/fil. A2/Ekta EN100 @ 125ASA/exp. auto/***JG**

Green and yellow fields
The 100ASA speed films are ideal for landscapes when you need faithfully recorded greens, yellows and blues. EN100 and Fuji 100D perform especially well with all types of filtration.
*400mm/fil. 81A/Ekta EPR/ tripod/***JC**

Film

Footballer, Seychelles

Faster film was required to freeze the lad heading the football. The colour saturation and the grain structure and sharpness are good with the medium to high speed E6 films but not as good as the slower E6 films or Kodachrome. Unless shooting for a grainy effect, use the slowest film the light conditions will allow.

*400mm/no fil./Ekta FD200 @ 300ASA pushed ½ stop in processing/exp. auto, approx. 350th @ f3.5/tripod/*JG

Early morning, Antalya harbour

3M 1000 film is used here for effect, not because of insufficient light. The large grain structure and the soft colours produced a rather abstract, unreal quality. I exposed for the highlights, which was 1 stop under the camera's meter reading. Shot on slow film, exposed normally on a normal lens, this could have been a pleasant harbour scene. The camera can lie.

*300mm ×1.4 teleconverter/3M 1000 @ 1500ASA pushed ½ stop in processing/exp. auto + 1 stop/ tripod/*JG

Shepherdess, Morocco

Shot out of the window of the car on a 300mm lens plus a ×2 teleconverter. It was necessary to use EL400 uprated to 800ASA to capture the picture in the low 7am light and because of the loss of 2 stops through the use of the ×2 teleconverter.

*300mm ×2 teleconverter/fil. 81A/Ekta EL400 @ 800ASA pushed ⅔ stop in processing/exp. 125th @ f8/camera supported on bean bag/*JG

Film

Ball

There are several films made for tungsten light. EPY has the slowest speed of these films, and makes reds and yellows look particularly good when the room is well lit. It is also a good portrait film when shooting at home – opt for a tripod rather than a flash, though it can be filtered to turn it into a type B light source.
*35mm/fil. KR1.5/Ekta EPY/ tripod/***JC**

Grand Canal, Venice

Fast film used for its soft romantic qualities in the most romantic city of all. Nearly dark, it was shot with an 800mm lens from the Rialto Bridge. I could have used a slow film with a very slow shutter speed, but the gondolier would not have been sharp. Exposed for the water.
*400mm ×2 teleconverter/fil. KR3/3M 1000 @ 2500ASA pushed 1⅓ stop in processing/ exp. auto + 1 stop/***JG**

Paris
What does a romantic Parisian do on a Saturday night? Buy flowers of course! The new range of very fast push films mean you can hand hold and shoot in very low light conditions. Very sharp and tight grain structure.
*85mm/no fil./KD EES @ 1600ASA/exp. 125th @ f2.8/*JC

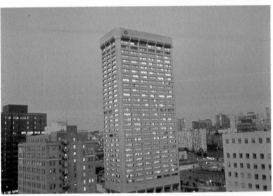

Seattle, USA
Shot in the early evening before sundown, using film designed for artificial light. The buildings have been turned blue by the remaining daylight, while the office and street lighting have the correct colour balance. This effect is often used in the cinema.
*28mm/no fil./Ekta EPY160 @ 200ASA/exp. auto/tripod/*JG

Paris
The cafés in St Germain look warm and friendly on a winter's night. This is in theory the wrong film for tungsten lighting. To be correct I should have used type B film. However, the resulting orange cast doesn't bother me. The low light conditions forced me to use EES film rated at 3200ASA. An 82C filter would have separated the skin tones from the orange background without much loss of film speed.
*85mm/no fil./exp. 60th @ f2/*JC

Film

Kodachromes

These are the sharpest films available – no grain with sharp edge detail. All have to be processed by Kodak – there is no control over the processing. We use the professional packaged film, it is the same product as the amateur. Kodak just test it and refrigerate it when it's perfect. Too young Kodachrome is greeny while too old is magenta. For the best results, Kodachrome should be shot in good clean bright light. It will take long exposures but there is a shift in the colour balance.

Kodachrome 25 (KM): Warmer than 64 and not so contrasty, the colours are, therefore, smoother and subtle. Very good skin tones. One of the few films that overexposes well.

Kodachrome 64 (KR): Compared to Ektachrome a little cold but helped with 81 filtration, and rated at 80ASA it has brilliant colour saturation. It is a contrasty film that polarizes well in hard light. Always looks better slightly underexposed as it holds shadow detail very well. A good film in shadowlight.

Kodachrome 40 (type A): Balanced for photolamp light (3400). Has all the qualities of the other Kodachromes. In tungsten light an 82A filter should be used. Unfortunately only available in the United States.

50ASA

Both these films are very sharp and grain free, but not as sharp as Kodachrome. Because they are E6 processed you can clip test them and then control the processing.

Fuji 50D: Rate at 50ASA. Good saturated colour, especially the blues. Filters well and polarizes even better than Kodachrome. Pinkish skin tones because it's biased towards magenta. Good sharp edge detail.

Agfa RS 50: Generally warmer than Fuji and not as contrasty. Softer tonal rendition, and very sharp.

100ASA group
The most popular range of films.

Fuji 100D: Sharp and bright, good grain and the natural choice if the light is suspect. Very good greens in difficult light. Very good edge sharpness.

3M 100: Grainier than the rest – so should be used if grain will enhance the picture. 3M makes the majority of film sold under supermarket or chemists' brand names.

Ilford 100: Rated at 100ASA it is a good, clean, bright film – an alternative to the other three.
Agfa RS 100: Displays all the required qualities. Minimum grain, good tonal range, although the skin tones are pale.

EN 100: The replacement for ER64 – good skin tones and primary colours, especially red and blue. Sharper than the old Ektachrome. Rate at 125ASA – good saturation.

200ASA
This medium speed ASA film is a good general film for the traveller, you can handhold in most light conditions. Not too fast for the bright sun, nor too slow for the dark shadows.

ED 200: Displays all the qualities and characteristics of Ektachrome: good grain, colour rendition and detail throughout the range. Better saturation if it's rated at 250ASA, but can be pushed 1 or 2 stops successfully.

AGFA RS 200: An alternative to Ektachrome – its natural blue tones need 81 filtration. Much improved grain structure on old Agfa film. The new RS films are very consistent no matter what E6 processing lab is used.

Film

400ASA group
Favourite with sports
photographers or when
you need a fast shutter
speed with a long lens.

Kodak EL: Needs to be
rated higher than 400 and
expose for the highlights.
It's a naturally cool film so
takes 81 filtration very
well. Rated at 800ASA the
increased contrast
sharpens the look of the
picture. Good film for
mixed light conditions.

Fuji 400: Good skin tones,
highlight and shadow
detail. Can be pushed up
to 1600 with slight
increase in grain. Filters
very well in fluorescent
light with FLD filter. As
with all Fuji films it adds
brightness to the picture
in difficult light
conditions.

3M 400: Gritty sharp
grain that looks
particularly good on the
out of focus backgrounds
when using a lens at
maximum aperture. Has a
good 'rustic' feel.

The high speeds
This range of fast ASA
films has recently been
introduced . A clip test
should be done first before
they are processed. At the
higher ASA settings these
films all tend to
underexpose by about ½ a
stop.

Kodak EES: Push film.
Can be rated from 800 to
3200ASA. Its most
consistent rating appears
to be 1600ASA. Holds
details in the shadow area
very well so expose for the
highlights. The more it is
pushed the more orange it
becomes.

Agfa RS 1000: Good soft
grain that doesn't increase
if it's used at 2000ASA. A
good choice for bluish light
conditions.
3M 1000: Big tight grain
but very sharp – looks
good pushed two stops,
there is an increase in the
grain size but it's used for
its painterly effect.

Fujichrome 1600: Not an
E6 process – has to be
mailed back to Japan for
processing in their P2
process. Very good for
yellows, greens and
orange colours.

Tungsten light film
(type B)
These films are balanced
for interior light
conditions.

It is possible to use the
faster ASA daylight films
and filter them for
tungsten light. Use a 40
red filter in fluorescent

light with type B film – it's
not perfect but it won't
distract from the picture
content.

EPY: Very good skin
tones and primary colours.
Pushes 1 stop
satisfactorily with no loss
of quality or shadow
detail.

EPT: Good general film
for tungsten light – expose
for the highlights. It
doesn't push particularly
well, there is an increase
in the grain size.

3M 640T: As with all 3M
films the tight black grain
is apparent but its extra
speed and true colour
rendition make it a useful
film.

Ektachrome Infra-red
You have to experiment
with filtration as there is
no 'correct' colour. Use the
yellow and orange filters
designed for black and
white photography and
Kodak Wratten 87, 88A
and no. 12 filters. At dawn
and dusk uprate to
160ASA. Always bracket
1 stop either way and store
in the fridge.

Polachrome
This film can be processed
within minutes of
exposure, if you have room
to pack the auto processor.
Like all Polaroid films, it
only produces true colour
in warm temperatures,
ideal for summer holidays.
Good colours with tight
apparent grain.

Agfa Dia-Direct
A black and white
transparency film with
very wide exposure
latitude. Holds highlights
without loss of shadow
detail. A useful film when
the weather is dreadful.
Has to be processed by an
Agfa lab.

Filtration

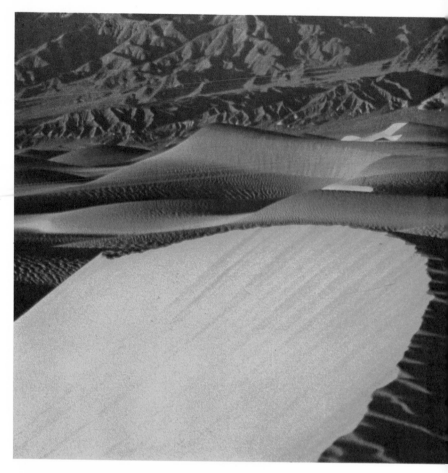

Filtration is probably the least understood aspect of photography, but it can add a new dimension to your pictures. The lens is to the film what the eye is to the brain. Both transmit visual images to their respective receivers. The great difference is, of course, that the camera has no soul and no fund of remembered images. The camera can have no emotional response to the images it receives.

The brain, however, is capable of juggling and mixing the images that it receives. It is not only concerned with the visual facts but it can add an emotional dimension to the image that the eye sees. This is what is meant by *the mind's eye*.

Photographers sometimes complain that the film 'just didn't pick up the right colours'. This can be true, but it is more often a case of the 'mind's eye' seeing more colour, or even a different colour. It is difficult to record emotional qualities such as atmosphere or mood on film. A good photographer understands that this can be a function of filtration – to supplement the film's deficiencies in certain conditions, to add colour in order visually to express these emotional qualities on film.

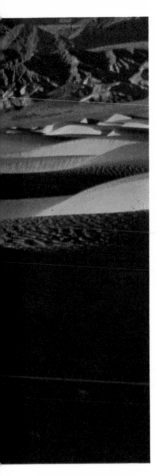

Death Valley, California

Photographed in the late afternoon. I left the family by the hotel swimming pool. The sand dunes looked cold, dirty and disappointing. It was my first experience of desert sand dunes and they were not as I had imagined them. To warm up the colour of the dunes I used an A12 filter, the strongest of the 81 series. This put colour into the sand, and made a picture that was my mind's eyeview of the desert.

I cropped the top off the large picture because the filtration would have killed the blue of the sky. Two hours later this filter would not have been necessary – but I might not have found my way back out of the desert in the dark.

80–200mm zoom @ 150mm/fil. A12/Ekta ED200 @ 250ASA/exp. bracketed @ f16/JG

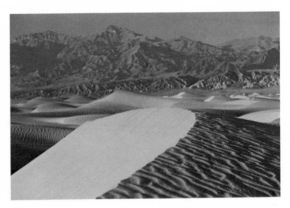

Many photographers resist filtration. Purists consider it to be cheating. However, it is important to bear in mind that film is manufactured to operate consistently under ideal conditions, say midday sun on the Equator, and obviously, therefore, the majority of pictures are shot in less than ideal conditions. Filtration can correct these conditions, making it possible to record on film the picture one hopes to see.

The most successful filtration should hardly be noticed. Just as in successful cooking the chef adds subtle spices to give the fish an individual flavour, so filtration does the same for a photograph.

Filtration for pictorial effect, when correctly used, is only doing what God's light does on a good day. A competent photographer needs to be capable of using filtration to achieve what he wants when light conditions are bad or when it is physically impossible to wait for ideal conditions. When travelling, the constant frustration is being in the right place at the wrong time.

Filters are not a magic formula for making perfect pictures. The secret is to know when and why they should or could be used.

Warming filters

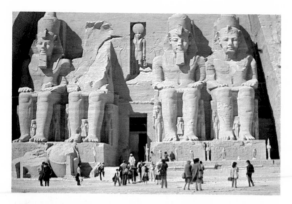

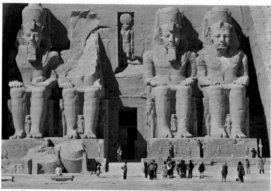

Abu Simbel
The top picture of the temple is perfectly acceptable with no filtration. The hard morning light has made the stone look like concrete. For the bottom picture a warming 81B filter was added, which has warmed the stone. The temple now looks 3000 years old. The level of contrast has been increased, giving the facade more depth.
*135mm/fil. 81B/KD64/mid-morning light/tripod/***JC**

Snowboy, Austria
This is the typical blue colour of unfiltered snow combined with the underexposure caused by the camera exposing automatically for the snow. Should have 81B or KR3 filter.
*35–105mm zoom @ 105mm/no fil./Ekta ER64 @ 80ASA/exp. auto/***JG**

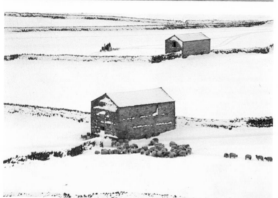

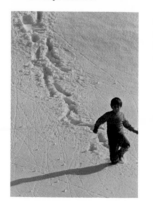

Snow landscape
Snow and shadows photograph with a blue cast. Here an 81B filter has eliminated the blueness and kept the snow clean. Correct exposure is also critical, so for insurance bracket in ½ stops up to +2 stops.
*135mm/fil. 81B/late afternoon light/tripod/***JC**

Fields
The warming filter has been very effective in this picture – photographed on a long lens, which has compacted the bluish haze in the distance. The 81A has neutralized this blue, and besides adding colour to the yellow rape it has strengthened the green. A very useful filter for landscapes, especially if photographed in the 'bluish' morning light.
*400mm/fil. 81A/Ekta EPR64/ exp. 15th @ f16/tripod/***JC**

Greek lady
This is a typical 81A filter picture. I leave the 81A on for most portraits, unless there is a greenish tinge to the light, when I may change to KR3 or A2. The 81A adds strength to the skin tones of a face. I don't like bluish skin tones unless there is a good documentary reason for it.
*80–200mm zoom @ 150mm/fil. 81A/Ekta ER64 @ 80ASA/exp. auto/***JG**

Nude
Shot in windowlight. The 81EF made the skin tones rich and brown. In combination with the Softar filter it smoothed out the skin texture.
*85mm/fil. 81EF + Softar/Ekta FL400 @ 500ASA/exp. for highlights/***JG**

Warming filters

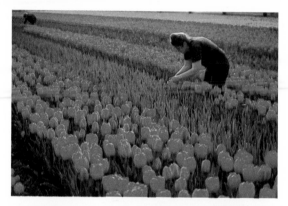

Tulips, Amsterdam
The KR filters are terrific for zipping up reds, as you can see here with the tulips.
*80–200mm zoom @ 80mm/fil. KR3/Ekta EN100 @ 125ASA/ exp. auto/***JG**

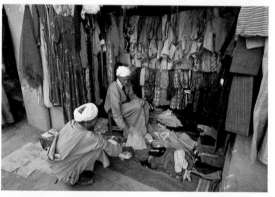

Berber Market, Morocco
Shade light is inclined to be bluish. The A2 (pinkish colour) cleaned up the blue and kept the bright colours bright. The white turbans are a neutral white, proving that the filtration is correct.
*28mm/fil. A2/KD64 @ 80ASA/***JG**

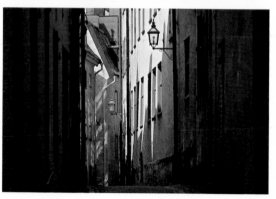

Stockholm alley
The 'clear' morning light looked too cold, so I used an extreme warming filter to make it appear as if it had been photographed in the late afternoon.
*180mm/fil. KR12/KD64/ tripod/***JC**

Man in Chitral
Strong light shining
through green leaves
gives flesh a green hue.
*105mm/no fil./KD64/***JC**

Couple, Turkey
The KR3 removed the
green skin tones caused by
the light coming through
the green leaves and
enhanced the suntanned
skin.
*35–105mm zoom @ 40mm/fil.
KR3/Ekta ER64 @ 80ASA/
exp. auto/***JG**

Venice
With and without KR12
filter. The shot with the
KR12 is effective because
there is already strong
colour in the picture, and
the filter has simply
altered it. There is also a
star filter on both shots.
*105mm/fil. KR12 + star/Ekta
ER64 @ 80ASA/exp. bracketed
(−¹/₂ stop)/tripod/***JG**

Nile
The paddle steamers at
Luxor are lit by the last
rays of the setting sun.
The light at this time of
day is at its warmest and it
photographs as if a KR12
filter had been used. It is
nature's version of a
warming filter.
*85mm/no fil./Ekta ER64/***JC**

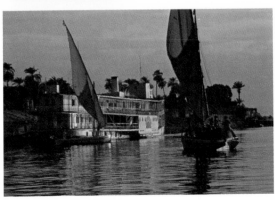

Polarizing filters

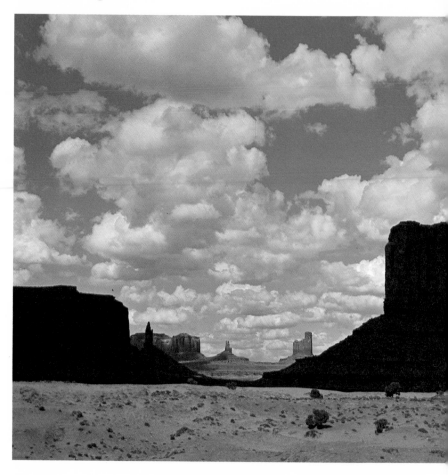

When you are using colour film, the polarizing filter is an important tool. It cuts out reflected light in the same way as Polaroid sunglasses, except that the filter can be turned to 'dial in' as much polarization as you require. By cutting down the amount of light reflecting off the subject it increases the colour saturation and the contrast in the picture, i.e. it intensifies the colour. If all you are after is colour saturation but no increase in contrast it is better to use a warming filter and expose for the highlights.

In cold flat light such as a cloudy day, polarizing filters simply increase the blueness of the light. This filter needs sunshine, ideally from directly behind the camera, especially if you are using a wide angle lens. When the filter is being used to cut out the reflections in windows or to see into water, sunshine is not important. It is safer to bracket your exposures, as the camera meter on auto will tend to overexpose.

As in the picture above the polarizing filter is good for clouds, but it is also good for wet and dusty leaves – cutting out the reflected light makes the leaves greener. The filter is useful around water, but expose carefully.

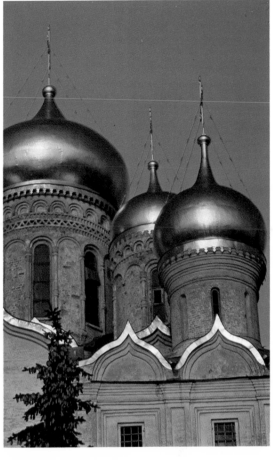

Monument Valley, USA
The polarizing filter has done its job of strengthening the sky by making the blue darker, and of increasing the contrast between the light and the dark areas of the landscape. This shot would have been less dramatic without the polarization.
*80–200mm zoom @ 130mm/fil. polar./KD64 @ 80ASA/midmorning light/***JG**

Moscow
Polarizing filters do not get rid of the reflections on a metal surface. The gold leaf on this Kremlin church shines more brilliantly in the picture because the filter has darkened the sky. All the right ingredients for polarizing were present here. The light was hard, and right behind the camera, the building had hard edges and I could use a tripod and Kodachrome. I chose an 80–200mm zoom at about 135mm, but with a bellows lens hood which increased the contrast of this lens.
*80–200mm zoom @ 135mm/fil. 81A + polar./KD25/hard morning light, January/tripod/***JC**

Polarizing filters

Abstract, Sydney
Shot out of car window
while stuck in traffic jam.
The polarizing filter has
intensified the yellow and
red and darkened the sky
by cutting the reflections.
Polarizing filters are often
used for hard-edged
abstract colour –
especially with the
sharpness of Kodachrome.
*24mm/fil. polar./KD64 @
80ASA/midday light/exp. auto
– ½ stop/*JG

Tuna fish, Canaries
The polarizing filter
makes an effective neutral
density filter when it is
used to reduced the overall
light level in a picture. It
is used here to reduce the
reflection off the fish. I
exposed for the highlights
and this has got rid of the
rubbish lying on the beach
– turned it all black.
*35mm/fil. 81B + polar./Fuji
50D/hard midday light/*JC

Corfu
Polarizer used here to look through the surface of the water by eliminating the reflection of the sky.
*28mm/fil. polar./Ekta ER64 @ 80ASA/exp. auto −1/3 stop/***JG**

Sugar plantation, Brazil
Travelled all the way to the Mato Grosso and it looked a bit like Gloucestershire! I had to try to make it look a little different. I used an 81B to brighten up the greens, a 1-stop (×2) blue grad. and a polarizer.
*35mm/fil. 81B, 1 stop blue grad. + polar./KD64/exp. @ f8/tripod/***JC**

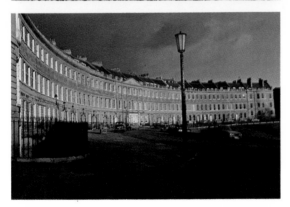

Bath
Nature sometimes produces a light that makes things appear on film as if you had used a polarizing filter. This usually happens after a thunderstorm. The sky is still black but the sun comes out opposite the black sky and bathes the subject in hard light. Exposed for the highlights.
*35mm/fil. KR1.5/KD64/late afternoon light/tripod/***JC**

Graduated filters

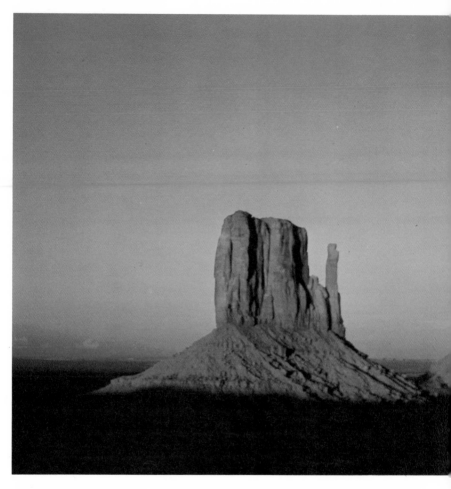

These are filters that add colour and tone to a chosen area of the picture. They are used when the exposure range, from light to dark, is too great for the film to reproduce, or when you need to add colour to one area of the picture for a special effect.

Often they will make a picture when there wasn't one technically there to be made because of the conditions. They do add drama, but beware of overgraded pictures which are too gimmicky and become tedious.

Because of the structure of graduated filters, it is inadvisable to stop down too much, especially when using wide angle lenses, as this can result in a sharp line across the picture. Using a polarizing filter with a grad. minimizes this effect.

Don't buy a round grad., that screws into the lens, buy the oblong type as this allows you more control. You can move the filter to cover the exact area that needs filtration.

One danger when using grads. is flare, the large area of the filter 'picks up' light and ruins the picture. Use a lens hood or a piece of card to 'flag-off' the offending light.

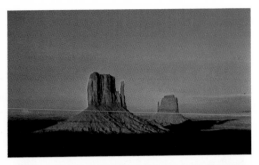

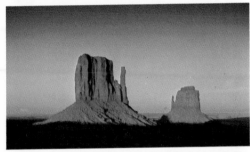

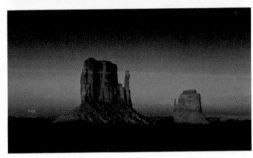

Monument Valley, USA
The picture top right is the valley as it actually looked, with no filtration. For the second picture I added a KR3 filter to intensify the warm colours of the rock, plus a ½-stop neutral density filter, but the lens was stopped down too far and the line of the graduated filter has come into focus. The third picture is shot with a 1-stop grad. which is too strong and also underexposed on an exposure bracket.

The large picture has a KR3, a ½-stop neutral density grad., and the lens is on maximum aperture (the line has disappeared).

Use a tripod when experimenting with filter combinations, and bracket the exposure. Use the preview button to check the line effect. Take your exposure reading *without* the grad. filter on the lens. *35–105mm zoom @ 70mm/fil. KR3 + ½-stop ND grad./ KD64 @ 80ASA/exp. bracketed/tripod/***JG**

Graduated filters

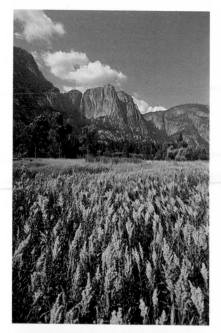

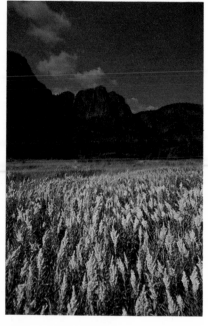

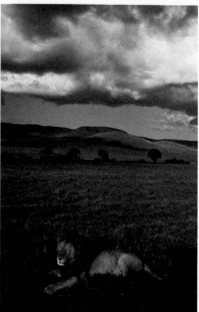

Yosemite National Park
Left: shot without a filter,
it is a landscape with
flowers.
Right: with a 1-stop ND
grad. filter to darken the
sky and mountains, the
flowers now dominate the
picture.
*24mm/fil. 1-stop ND grad./
Ekta EPR64 @ 80ASA/exp.
normal without filter/***JG**

Ngorongoro crater
Threatening
thunderclouds have
darkened the sky, as
happens when you use a
grad. filter. Grad. filters
only do what God can do on
a good day.
*28mm/no fil./Ekta EL400 @
500ASA/exp. auto −1/2/***JG**

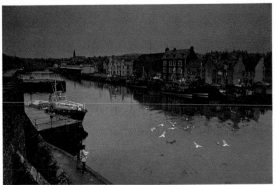

Eyemouth

During the winter there are days that are just grey and damp, with no colour at all. Rather than try to improve these conditions, why not exaggerate them? Here a 2-stop neutral density grad. and a 10 blue filter have combined to make the day even more miserable.

*35mm/fil. ND grad. +10 Blue/ KD64 (always looks grey in these conditions)/tripod/***JC**

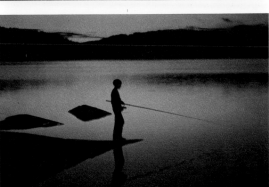

Sunset in Sweden

During the summer the sunsets in the northern hemisphere take several hours: the afterglow lingers. The natural pink in this picture was too pale, so I used a pink grad. to boost it up.

*85mm/fil. pink grad. (Lee Filters)/Ekta ER @ 80ASA/ tripod/***JC**

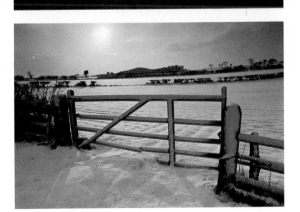

Snow-gate

The exposure range here is considerable. If I had exposed for the sky, the gate would have been a silhouette; if I had exposed for the detail on the gate the sky would have been white. The 3-stop neutral grad. has evened out the overall exposure, and kept detail throughout the picture.

*24mm/fil. 81A + 3-stop ND grad. (Lee filters)/KD64/ tripod/***JC**

Effect filters

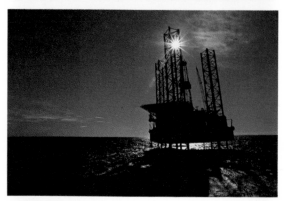

Nicholas, Cornwall
The morning backlight
seemed to suit a soft focus
filter. Shot for a dreamlike
effect. Experiment with
the Softar in different
light conditions.
*80–200mm zoom @ 90mm/fil.
Softar 1 (Hasselblad with
converter)/Ekta ER64 @
80ASA/exp. auto/JG*

Venice
The Softar filter has had
the effect of adding a
subtle mist to this 7 a.m.
light. The lens was
stopped down to f11, so
minimizing the softening
effect: with the lens wide
open it would have looked
much softer.
*85mm/fil. Softar 1
(Hasselblad with
converter)/Ekta EN100 @
125ASA/exp. 8th @ f11/
tripod/JG*

Oil rig, Tierra del Fuego
This is a star-effect
produced by the wide
angle lens when stopped
down to minimum
aperture. The sun has to
be partially hidden, as by
the rig.
*20mm/no fil./Ekta ER64 @
80ASA/exp. 250th @ f22/JG*

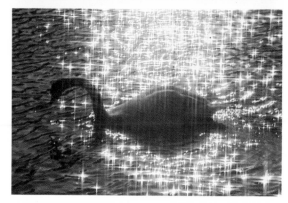

Swan, Cornwall
The star filter worked well
off the backlit water. Star
filters only work off point
sources of light.

Underexpose to
compensate for the glare.
*80–200mm zoom @
200mm/fil. star (Hoya)/Ekta
ER64 @ 80ASA/JG*

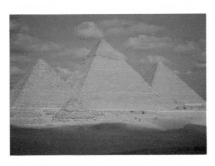

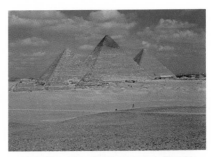

The Pyramids
1 no filtration
2 a coloured polarizer
By rotating the outer filter you can dial in as much red tone as you require. It adds colour to the polarized band of light.
*Both 80–200mm zoom/Ekta EPR/exp. auto + bracketing/ tripod/***JC**

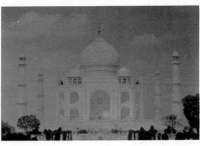

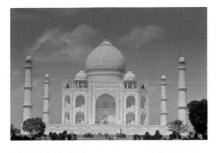

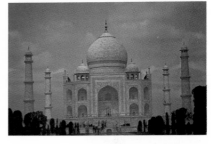

The Taj Mahal
1 Spirotone blue filter. This can be used either with or without a polarizer. Here it has been used without.
2 & 3 Spirotone red filter with a polarizer. By rotating the two you can change the colours of the things in the picture. These filters come in several colours. You can't tell exactly what the final result will be.
*35–105mm zoom/Ekta EPR/ exp. auto + bracketing/***JC**

Corn
The orange filter should really be used for black and white photography, but I used it here to add more interest to the sky. Exposing for the sky has turned the wheat into a silhouette.
*24mm/KD64/125th @ F16/ tripod, lying on my back!/***JC**

Filtration in difficult conditions

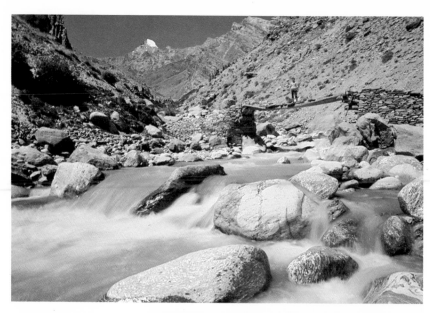

Too much light
High up in Zanskar we would cross these fast running streams many times a day. This particular one was good looking and coincided with a lunch stop. The light was so bright that even when the lens was stopped right down the shutter speed was too fast to give the sense of movement I wanted. So I used a neutral density filter to reduce the exposure by another two stops. The shutter speed was now 1 second, which was slow enough to make the water appear to be flowing. Stephen stood on the bridge to give the picture scale.
*24mm/fil. 81A + 2-stop ND/KD64/exp. @ F22/tripod/*__JC__

Fluorescent light
If this picture hadn't been filtered, the people and cakes in this brightly-lit Paris patisserie would

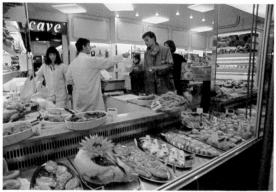

have appeared green, because film doesn't work well in fluorescent light. The colour cast can be corrected by using a colour temperature meter, which analyses the light and tells you what filter combination will give white light. If you know what type of fluorescent tube it is, you can also work out the right filtration. Both methods are

impractical and cumbersome for the traveller, as you have to carry a dozen or more filters. It is easier to use a 30 magenta or an FLD filter. Both work well, but to make sure the picture won't be cold I also use an 81B filter. The 30 magenta also doubles as an effective sunset filter.
*24mm/fil. FLD + 81A/3M 1000/exp. auto/*__JC__

Snow

On a sunny day 80 or 90 per cent of the light is reflected off the snow. This fools any type of meter, resulting in 1½ to 2 stops underexposure, which is one of the reasons why the snow looks so blue and dark. To keep it fresh and white, and figures more than just silhouettes, use the exposure compensation button set at plus 1½ or 2. The safest way is to take an incident light reading, to measure the light source (that is, the sun) not the light on a subject. However, this is only possible with a hand meter. If in doubt refer to the information that comes with the film package and use the recommendation for 'bright and sunny'.

A polarizing filter will reduce the reflected light; but expose carefully – there is already considerable contrast and the filter will increase it, especially if you underexpose. At high altitudes, if you shoot straight up, a polarizer will turn the sky black. I always bracket with a polarizer. There is much more ultraviolet at high altitudes and an ordinary UV filter is not strong enough to correct the blue haze, especially for mountainscape pictures; in this case, use an 81B or a KR3.
*135mm/fil. KR3/Fuji 100D/exp. auto + 2 stops/***JC**

Tungsten light

There are several ways of handling interior light. You can shoot on type B film – the correct film for tungsten light – or you can correct daylight film with an 80A filter. Both methods produce a picture that is too pure: there should be a warm light, making it feel homely. I use a KR3 or KR6 with type B film, and 82C with daylight film. Both produce the desired effect, as in this picture of Odins, one of London's top restaurants. Not only is the food excellent but the decoration is warm and welcoming.
*28PC/fil. KR3/3M 640T/ tripod/***JC**

Natural light

So often the sole reason for taking a picture is the way the light falls on a subject. Light can make the mundane special. The quality of light changes with every minute of the day, and every day of the year; and a photographer who travels will see that it changes with every degree of latitude, too. The light just after dawn on a Greek island in June is the same sort of light as you see in Moscow in the middle of a fine January morning.

The ability to interpret light, to see how it will translate on to a particular film, is the most important skill required by a photographer (especially a travelling photographer). This skill can't be acquired overnight, or learnt in a classroom. You can only learn by going out and constantly observing. Light to us is inspirational; it is the magical ingredient.

There is no such thing as bad light. There is difficult light – certain conditions are obviously not encouraging, but they are always controllable and can be used to advantage, especially with modern film, lenses and filtration.

Throughout the book there are pictures that have been taken in light conditions which many photographers would consider to be unsuitable. Remember that in bad light the content of the picture must be strong.

Dal Lake, Kashmir, January
The light is soft and all colours appear pastel. In winter the light is very blue. During a clear dawn the eastern sky goes through many subtle colour changes, all of which photograph beautifully – well worth getting up for.
500mm mirror, these lenses are naturally blue/no fil./

Ekta 64
*(good for pastel tones)/slightly underexposed to increase blueness/tripod/**JC***

Fuerteventura, December

As the sun appears over the horizon, the direct light is very clean. Sunrise is over very quickly. Many grey, cloudy days are preceded by clear dawns. During the summer it is the best time of the day. Sunrise light is good for photographing mountain and hilly landscapes.
*85mm/no fil./Fuji 100D/ tripod/***JC**

Beyond Port Stanley, The Falklands, July

One of the best lights for aerial and general landscape photography is in the early morning, soon after dawn. The light is bright and clean and there is little ultraviolet haze.
*35mm/fil. KR15/Ekta EPR/ exp. auto @ 500th (safe speed for aèrial pictures)/***JC**

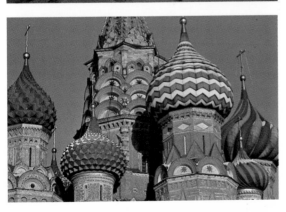

Moscow, January

The hard morning light has picked out the intricate domes of St Basil's Cathedral. The sun is still relatively low in the sky but you can feel its warmth. In winter this time of day brings a pure crisp light that polarizes well. In summer it's soon gone as the sun moves quickly into the sky.
*80–200mm zoom/fil. 81A/KD64/tripod/***JC**

Natural light

Windsurfers, Spain, mid-morning
This light happens twice a day, mid-morning and again mid-afternoon, when the sun is high in the sky but not directly overhead, hitting the ground at an angle. It is 'whiter' in the morning; by the afternoon a yellow cast has started to appear. A good general light but nothing special.
500mm mirror (the doughnuts added to the sparkle already there)/Ekta EN100/exp. auto but clipped and judged/tripod/ **JC**

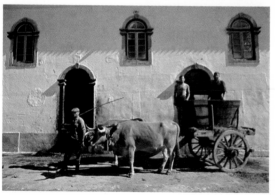

Grape harvesters, Oporto, late morning
This is the time of the day in hot countries when shadows are strong and the light has very good definition. The sun is not yet overhead so faces are still well-lit. Also a good time to shoot buildings and anything you want sharp and well defined.
105mm/KD64 @ 80ASA/exp. auto/ **JG**

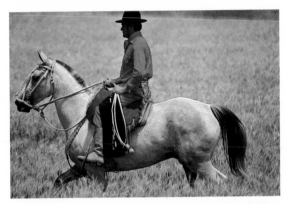

Gaucho, Argentina, noon

At noon the sun is directly overhead, sending the face into shadow. Difficult light for portraiture, often used for hard-edged graphic shots with plenty of blacks and strong colour – not for subtle effects. I am using the gaucho and horse as a shape against the wheat field, not as a personality. Be careful of exposure at this time: if you expose for the shadow the highlights will be washed out. It's more effective to expose for highlights and leave the shadows black.

*300mm/fil. 81C/Ekta ER64 @ 80ASA/exp. auto −½ stop/***JG**

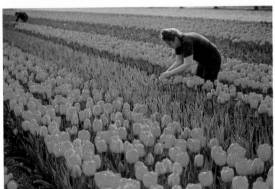

Flowers, Amsterdam, mid-afternoon

The angle of the sun has lowered enough to use as a subtle backlight. A flattering light for people and objects. The colour is starting to warm up.

*80–200mm zoom @ 150mm/fil. KR3/Ekta EN100 @ 125ASA/exp. auto −⅓ stop/***JG**

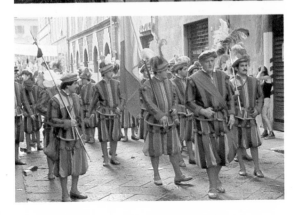

Bombardiers, Florence, afternoon

The sun is going down, but still two hours of warm flattering light remain for photography. The time of warm colours and long shadows. Effective whether using backlight or frontlight. This portrait was 'made' by the quality of light falling on the bombardiers.

*80–200mm zoom @ 200mm/fil. KR3/Ekta ER64 @ 80ASA/exp. auto/***JG**

Natural light

Sweden

The sun is low, but has not yet started to set, it is still shining. A magic light, that is direct and very yellow. Everything photographs well in this light, especially skin tones and buildings.
Unfortunately the magic moment doesn't last for long.
180mm/Ekta EN100/exp. for canoe using spot meter/tripod/
JC

Nazare, Portugal

Never chase a sunset. You must be in position and set up well before the sun starts to go down. If you want detail in the picture other than the ball of sun itself, take the meter reading at between one o'clock and two o'clock from a direct line with the sun (see Sunset spread).
*180mm/no fil./KD25 @ 32ASA/exp. auto/***JG**

Majorca

Dusk has the same soft unreal quality as dawn plus the colour left by the sun's glow. This shot was taken in the Port of Andrax.
*80–200mm zoom/fil. A2/Fuji 400 @ 500ASA/exp. auto/ tripod/***JG**

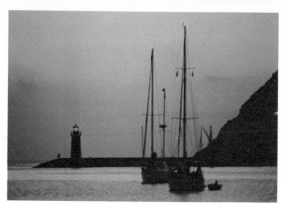

Yosemite, California
It was the backlight catching the water splashes that attracted my attention. I grabbed my camera bag and tripod from the car. It was 10 a.m.

The sun had just risen over the mountain, backlighting the boys and the river, but the mountain was not lit. I exposed only for the highlights (a reading off

my hand) and set the camera manually.
*500mm ×1.4 teleconverter/ Ekta ED200 @ 250ASA/exp. 1000th @ f11/tripod/*JG

Natural light

The Lama of Fuctal
Windowlight is very good for portraiture, glamour, and even still life, because it is soft and clean, especially in north light. You can control it easily: by rotating your subject you can change the effect of the light, or you can use a reflector to fill the shadow area. It is so versatile that you can use any speed film, either Kodachrome for detail or 1000ASA for softness.
50mm/KD64/exp. 15th @ f11/ tripod/**JC**

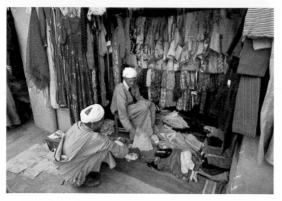

Berber market, Morocco
Shade light on very bright days is a flattering descriptive light for many subjects. The light is bouncing in from all directions, so there are no shadows. An A2 or KR3 filter is advisable, however, to avoid a bluish tinge.
28mm/fil. A2/KD64 @ 80ASA/**JG**

Donna

Backlighting is very flattering. To avoid lens flare use a long lens, which has a narrow acceptance angle. Here, a white building has acted as a large reflector, putting light back into Donna's face.

400mm/Ekta EPR/late afternoon light, same colour as Donna's hair/**JC**

Anya, Sweden

The gold reflector has kicked the light back into Anya's face with the strength of a flash fill and given it a lovely golden glow.

400mm/Ekta ER64 @ 80ASA/reflector – Rosco Space Blanket (gold)/exp. auto/**JG**

Antalya, Turkey

Dinner in Antalya. Using the window as a backlight, I exposed for the rosé wine and allowed the figures to go into silhouette.

35–105mm zoom @ 45mm/ Ekta ER64 @ 80ASA/exp. auto/**JG**

Difficult light

Corfu
The fish at the bottom of the picture are lit by daylight: they are the correct silvery blue of sardines. The colour of the fish gets progressively warmer the closer they are to the tungsten light. The face of the fishmonger, lit entirely by the tungsten light, is a strong orange colour. This is a good guide to the colour cast produced by tungsten light on daylight film.
*24mm/Ekta ER64 @ 80ASA/ exp. auto/***JG**

Fireworks, Cowes Week
There are two ways of photographing fireworks. You can either use fast ASA film and a slowish shutter speed or use a tripod with the camera shutter locked open. Between the bursts of fireworks cover the lens up with a piece of black card. This way you can record all the evening's fireworks on one frame. Don't allow the bursts to overlap too much. Automatic exposure meters are useless for firework displays. Use a tripod and a cable release, a slow ASA film at f11 and bracket with the shutter from ½ a second to 8 seconds. This approach should be used when photographing lightning.
*35mm/3M 1000/exp. 15th @ f2/unipod/***JC**

Sacre Coeur, Paris

Many fine buildings are sympathetically floodlit, making them stand out from their surroundings. The best time for photography is just as the sun has gone, as the remaining light in the sky will help the exposure. The floodlighting will be warmer on daylight film but the sky will be bluer on type B. The exposure reading should be taken off the building.

*28PC/no fil./Ekta EPY/exp. @ f11/tripod/***JC**

Streetlight, Yugoslavia

Sodium vapour lamps give a strong green cast with daylight film. As you can see, the boy's face is the colour of the Incredible Hulk.

*28mm/Ekta EL400 @ 500ASA/exp. auto/***JG**

Candlelight, Sacre Coeur, Paris

This picture is one of those that surprise you when you get home – it looks better than I imagined it would when I was taking it. It was so dark inside the Sacre Coeur that I didn't think anything would register. Candlelight is brighter than you imagine and warmer too – I should have used an 82C filter.

*85mm/Ekta EES pushed to 3200/exp. ½ @ f2/tripod/***JC**

Adverse weather conditions

Adverse conditions are only a problem if you and your camera aren't prepared for them. Cameras don't like: water, salt, sand, extreme temperatures and high humidity. People don't operate very well in these conditions either. The clothing spread will help you take care of yourself. Remember, you and the camera take the picture, so if you're not comfortable this could affect the outcome.

We have spent a lot of time working in Britain where we have learnt to use adverse conditions to our advantage. The Nikonos camera is the obvious choice on the beach, near water or in the rain. Using the tripod allows you the freedom to use an umbrella, and a supermarket plastic bag is a cheap and effective way of protecting the camera. The new fast ASA film makes it possible to take photographs in conditions that you once wouldn't have contemplated even going out in.

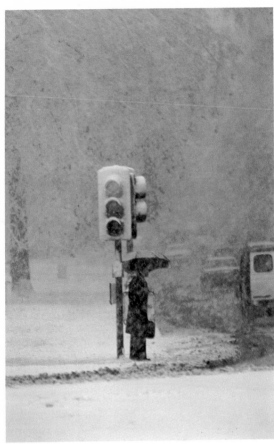

Wind and rain

I went to the Butt of Lewis in November in search of stormy weather. The forecast was severe gale force 9, a huge sea running and horizontal rain: just what I wanted.

Pinned to the rock side by the wind, rain and sea spray, the Nikonos handled the conditions perfectly. I took a general exposure reading, knowing I would have to clip-test the film before final processing.
Nikonos/35mm/Ekta EPD/ dawn light/250th @ f5.6 (judged clip at normal, increased processing by ½ stop)/JC

Blizzard

My attention was drawn to the lone figure about to cross the road. The red lights enhanced the picture. The camera and lens were protected by a large plastic bag, gaffa tape and an umbrella for insurance! I kept a chamois leather handy to clean the lens. I chose a long lens to 'compress' the falling snow so it would appear to be falling even more heavily, and I used a slowish shutter speed so that the snow falling close to the camera would not be sharp. The lens could look through the snow to the subject, 60 metres from the camera.
400mm/Ekta EN100/exp. auto @ 60th/JC

Adverse weather conditions

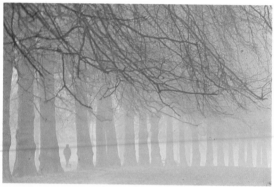

**Foggy morning,
Hyde Park**
Foggy mornings can make
beautiful pictures, but
photographers rarely take
advantage of them. Use a
wet weather housing or
carrier bag to keep out
moisture.
*180mm/no fil. for cold colour/
Ekta EN100/exp. f5.6/tripod/*
JG

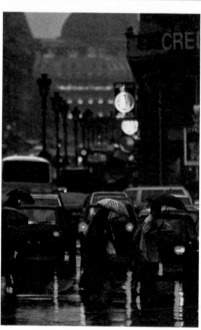

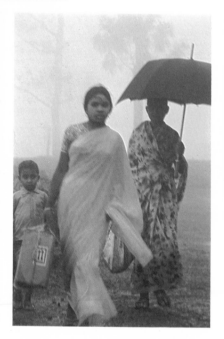

Paris, evening, winter
The prospect of the Paris
rush hour on a cold wet
winter's evening doesn't
make you reach for your
camera! First I had to find
a high camera angle away
from the bustle and spray.
The camera was protected
by a rubbish bag and an
umbrella. Even so, the
lens needed constant
attention for rain drops.
Near cameras it manages
to rain upwards!
*400mm/fil. A2/Fuji 400D @
1000ASA/exp. reading taken
off mid-tone area of picture/
tripod/*JC

Monsoon, Sri Lanka
I used my Nikonos with
the 80mm lens for this
shot. It isn't really sharp,
but it doesn't matter – the
feeling of the movement
and washy colour is good.
*Nikonos/80mm/no fil./Ekta
ED200 @ 250ASA/exp. auto
approx. 30th @ f4.5/*JG

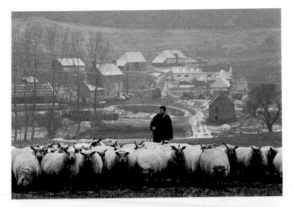

Shepherd, Normandy

A very cold sleeting morning, but the shepherd still had to inspect his sheep. The light was very low. I used my 135mm f2 lens wide open and pushed the EL400 to 800ASA and pushed 1 stop in process. I added a KR3, which has improved the colour.

*135mm/fil. KR3/Ekta EL400 @ 800ASA/exp. auto @ f2/***JG**

Monastery, Fuctal

To photograph in these conditions a tripod and cable release are essential. Take the exposure reading off a white card. There is a danger of overexposing even in these conditions. Because of the build up of exposure the camera is able to see more detail than your eyes, in the dark. For circular star patterns use an exposure of 2 hours with KD25 at f3.5.

35mm/KD64 no filter – brown colour is partially due to reciprosity/exp. 15 mins @ f8/JC

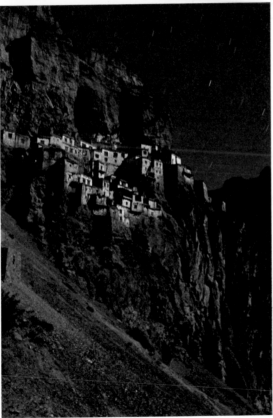

Adverse conditions – water

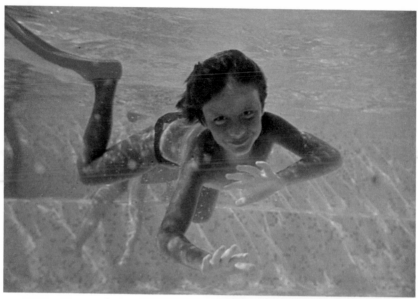

Nicholas underwater, Marrakech

This underwater portrait was taken in the Es Saadi pool at 12.30, an ideal time of day for underwater photography, to achieve maximum exposure value. Wear a mask or goggles, otherwise accurate framing is impossible.
*Nikonos IV/Ekta ED200 @ 250ASA/exp. auto/***JG**

Nicholas and shell

Underwater cameras are great little beach cameras. This is an example of the underwater camera used as a normal overwater camera. I positioned the arm to be in the same plane as the face and the shell in the hand so that it was clearly visible, and made a harmonious shape against the face.
*Nikonos IV/Ekta EPR64 @ 80ASA/exp. auto, approx. 500th @ f8/***JC**

Pola, Malindi
Underwater cameras allow extraordinary angles, like this one, with the lens half in and half out of the water.

*Nikonos IV/35mm/Ekta ER64 @ 80ASA/***JG**

Rainbow Warrior
I would have missed many pictures if I hadn't had a camera that could handle these very special conditions.
*Nikonos IV/Ekta EPD @ 300ASA/***JC**

Flash

Flash units should not be thought of solely as the last resort, to be used when it's too dark for an ordinary exposure, but as a piece of equipment that has enormous creative possibilities. Some photographers hate them because they never get reliable results but others are fans because they know when and why to use them.

Shooting colour transparency with flash has been a problem for many photographers because the flashlight duration is so short. Professionals often shoot Polaroid film so they can see immediately what the flash has done. Modern flashes calculate exposure in two different ways – through the lens metering (TTL) or by computer sensor; the most sophisticated units incorporate both and these offer most control.

TTL metering measures the light actually reaching the film in the camera. No longer do you need to make any complicated calculations. Computer flash monitors the amount of light 'hitting' the subject – you set the flash dial and then the corresponding aperture on the lens. With TTL all the f stops from f2.8 to f22 can be used, but with computer flash you are limited to three or four. TTL flash is a real improvement if you use only one flash.

Modern flash units use their battery power economically yet are still powerful. 250th sec flash sync means you can freeze a fast moving subject in daylight and still have detail in the background. You don't have to use the shutter speed marked on the shutter dial (usually in red): don't use a faster one but any slower speed is fine. If you want to use more than one flash buy another of the same, so that the recharge time is identical. You have more control if the secondary flash units are the dual type, both TTL and computer controlled, because all flash units have to be wired to the camera for TTL control to work. This is sometimes impractical, the secondary flashes may be a long way away and it's simpler if they are triggered by a photo slave unit. In these conditions computer flash works.

For consistently good flash pictures a flash meter is a wise investment. Remember the flash is only powered by six small batteries at most, so there's no chance that it's going to light up a player in a sports stadium 100 yards away.

The light from a handflash is too white. Use an 81B filter on the flash to warm it up. This eliminates that stark light effect associated with flash.

Woody

Woody is a hen who befriended us in America. Shot outside with 105mm macro lens. Lit by a hand flash – filtered with an 81A and 05R gelatine filter and held approximately 15cm to left of camera. The duration of the flash is so fast that we can see the wheat on the chicken's tongue, impossible with the naked eye.
*105mm/fil. 81A + 05R on flash/KD64 @ 80ASA/exp. auto/**JG***

Lesley

This is almost direct flash being used as a fill in light. The strong top light coming through the leaves was green, shadowy and unflattering. I took the exposure reading from the grassy background, i.e. 30th @ f5.6, and set the computer flash on f4. Fill in flash should not dominate, it should be used to keep the image 'clean'.

*135mm/81A filter on both camera and flash/Ekta ER/exp. 30th @ f5.6/flash on tele setting/tripod/*JC

Ruth

The sunlight was flashing off the rippling water, confusing the camera meter. To get a picture of Ruth I had to use a flash as the reliable light source. Took a normal exposure reading off the pool, then set the camera and flash on the same F no. The ASA on the flash was 80 so that it would slightly underexpose: I didn't want to overexpose her face.

*105mm/no fil. on camera, 81B on flash/Fuji 50D/125th @ f5.6/*JC

Flash

Coins, close up
A flash with a tele setting was placed at the same level as the coins. The hard light 'skimmed' across them, highlighting the base relief. Opposite the flash a curved white card has put light back into the surface of the coins. TTL metering has worked perfectly. Bracketed by altering the ASA dial.

*55mm macro + ring/Fuji 50D/tripod/***JC**

Montacute House
Direct flash on the camera was used here because the daylight was not picking out the intricate detail of the carving. A blast from the flash has done the trick. The flash and daylight were balanced. If the flash reading is f8 then adjust the shutter speed until the daylight reading is also f8. A long exposure allows the daylight to fill in and soften the shadows caused by the flash.

*35mm/no fil./KD64/8th @ f8/ tripod/***JC**

New Year's Eve, Sydney
A typical flash-on-the-camera shot. Shot on a Minox with the Minox auto flash. The lighting here is not exactly subtle but catches the moment. *Minox with flash/Ekta ER64 @ 80ASA/exp. auto flash/***JG**

Two Spanish guitarists
To avoid 'red-eye' use the flash away from the camera, either on a bar or held above your head. A motor drive makes it possible to shoot one-handed. I attach a wrist strap to the flash so I can focus without dropping it. *35–100mm/Fuji 100D/***JC**

Flash

Family dinner
The family were celebrating the end of the grape harvest in Cognac. As you can see, it was very crowded. Used two flashes; one bounced off the apex of the wall, camera right, and the other bounced down the far end of the room, camera left, triggered by photo cell. Slowish shutter speed so the room light registered.
28mm/Ekta ER/exp. @ 15th/ tripod/JC

Clare
This lighting set up here was done with three computer controlled handflashes. The backlight is set on f16, the main light f5.6/f8, positioned half-way between the camera and the model. The fill light f5.6, just above the camera. The camera was set on f8. The main light was bounced, the fill light heavily diffused and a Vivitar type B gel on the backlight to give the yellow colour. A flash meter was used to check the exposure.
85mm/fil. KR1.5/Fuji 100D/exp. @ f8/diffuser/ tripod/JC

At the bar
The front flash held high above the camera, diffused, and the side flash also diffused, and on the tele setting with a purple gel on the front, triggered by a photo slave cell.
85mm/fil. KR1.5/exp. 30th, main flash f5.6, purple flash f8/JC

Three heads
Divided the viewfinder
into three parts, did a trial
run of the picture and
marked the floor so Clare
would know exactly where
to stand. Darkened the
room, locked the shutter
open with the cable
release. Manually fired
the flash, Clare moving
after each flash.
*85mm/fil. KR1.5/Ekta ER/
bounced flash with 81B fil.*/**JC**

**Mathew running,
Richmond Park**
The flash was set on f8 and
the camera on auto
−1 stop − 30th sec @ f8.
The background blurred
on a 30th sec and the flash
froze Mathew in mid-
stride. The result has a
good feeling of speed. The
flash has zinged out the
colours of the tracksuit.
*35–105mm zoom/fil. A2/Fuji
400 @ 500ASA/exp. flash f8,
camera auto −1/***JG**

Taking the picture

Be prepared, with your camera loaded and your head in gear. The first frame can be the best so learn that checklist by heart. Get thoroughly familiar with your new camera or lens before you go on holiday, shoot a couple of test rolls, play with it while watching TV or whatever to get to know it well. Read the manufacturer's manual thoroughly.

A common fault with inexperienced photographers is to leave the subject too small in the frame. Be bold, fill the frame. Search the frame for the rubbish: good photography is as much a process of eliminating the ugly as it is a search for the beautiful. Train your eye to scan every millimetre of that viewfinder for any nasties that could spoil the picture, i.e. things sticking out behind heads, an old plastic bottle on the beach, etc. Get into the habit of using the preview button – you can only see the rubbish when you are stopped down.

Don't accept that your own eyelevel viewpoint is the ideal, look for other camera angle possibilities, lower or higher. Don't carry more equipment than is comfortable, you don't achieve better pictures. Don't get tense and worried about your pictures. Travel photography should be a great joy and relaxation, not a chore.

Holding the camera

Holding the camera correctly may seem obvious and unnecessary to mention, but it is amazing how many tourists we see with excellent equipment attempting to take pictures which, because of the way they are standing and holding the camera, can't possibly be sharp. Think of yourself as a tripod, or perhaps bipod. Stand firmly on the ground with your body weight slightly forward. Hook your elbows into your body with no arms flapping about. The left hand does the job of supporting the lens and focusing while the right hand holds the camera and releases the shutter. The same principles apply to shooting a gun – squeeze the trigger (shutter) gently into the camera, don't just stab at it with your finger.

Camera care

Most cameras taken in for repair don't have anything wrong with them, the batteries are just dead. The other major fault is caused by people not reading the camera manual properly. Don't buy a camera for your holiday as you would suntan oil, get to know it well first.

Photography is not only powered by batteries, it is controlled by them. Before you go on holiday put new ones in everything: cameras, flash, handmeter, etc. And take a spare set too.

For cleaning take lens tissues, blow brush, stiff brush, clean chamois leather and lens fluid. Always keep a filter on a lens, it will keep it clean. A lens hood will help. On the beach don't wear your camera if you are covered with oil, it will smear the lens, especially an underwater camera.

When travelling by air don't carry the film on you, whatever the airport authorities say, X-ray is likely to damage the film. Send it with the hold baggage.

A camera is a precious instrument, treat it with respect.

1
Totally the wrong
way to stand.

2 & 3
The right way to
stand.

4
Whether just
wandering around
a city or trekking
15 to 20 miles a day
in the mountains,
wearing the
cameras like this is
much less tiring on
the neck.

5
When working
fully equipped.
Long lens tucked in
behind you, camera
bag resting on the
hip – can be pushed
behind you if
crowded. Camera at
the ready.

Checklist

The foundation of good photography is a constant routine and good habits. A checklist is second nature to every top photographer in the world. Without it you'll never avoid the silly cock ups that ruin a potentially good picture. There are so many things that can go wrong. So check and check, and check again – not very glamorous, but the only way to take successful travel pictures.

1 Check – the correct programme

2 Check – shutter speed

6 Check – there is no hair trapped in shutter

7 Check – film is being taken up, rewind lever should rotate.

10 Check – you are shooting the right film

11 Check – always rewind when you have finished the roll

3 Check – ASA film setting

4 Check – exposure compensation dial is zeroed

5 Check – the shutter is not too fast for flash

8 Check – the film is wound on to the take-up spool

9 Check – The camera is locked

12 Check – lens elements are clean

13 Check – correct filter is being used

Portraits

A portrait is a picture taken when the subject is aware of the photographer and has agreed to be photographed. The biggest problem with travel portraiture is to break through the shyness barrier. Strangers are naturally shy of each other, even more so when one of the strangers wants to photograph the other one.

Most people are apprehensive about posing for a portrait. Our first priority as photographers should be to make them feel relaxed and comfortable. It is important that you project an air of confidence. The confidence will grow as you become more technically competent. The less you dither and flap the better everybody responds. Do not feel anxious that you have to rush a portrait: there is always more time than you expect.

We have learnt that it is always better to make an obvious, honest approach to the subject. They will not feel then that you are ridiculing or exploiting them. It is comforting to consider that when you take somebody's portrait you are performing a most sincere act of flattery!

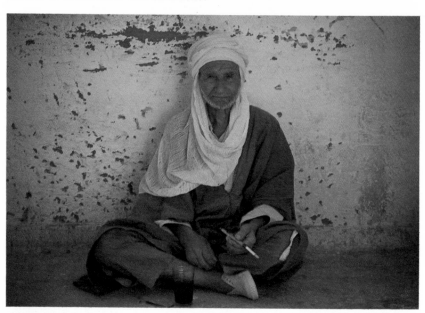

Algerian man
This Algerian man agreed to be photographed after I had bought him a mint tea and a cigarette. I chose a low camera angle to give the picture balance, in sympathy with his natural grace. He was never going to smile, he knew how he wanted to look!
*85mm/KD64/shadowlight/ tripod/*JC

Masai girl, Kenya
We met this girl *en route* to the Masai Mara. She agreed to pose in exchange for some sweets. The portrait is a simple description of the girl and her jewellery: she looked beautiful, therefore no tricky techniques were required. The Masai, like most tribal people, resent tourists sneaking pictures of them. They consider it bad manners and may react violently – so ask first!
*80–200mm zoom @ 160mm/fil. 81A/Ekta ER64 @ 80ASA/morning overcast/*JG

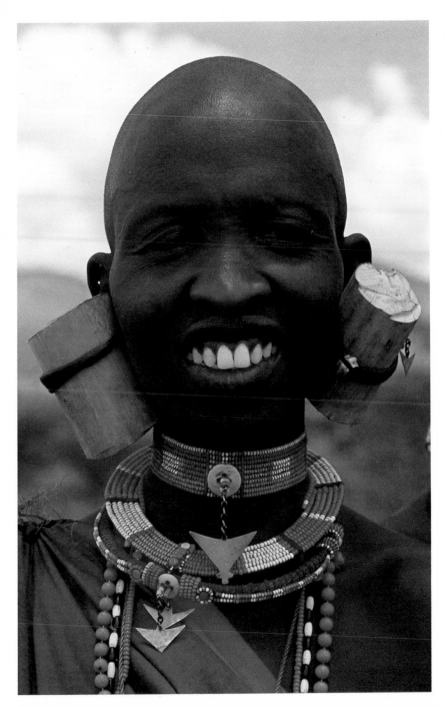

Portraits

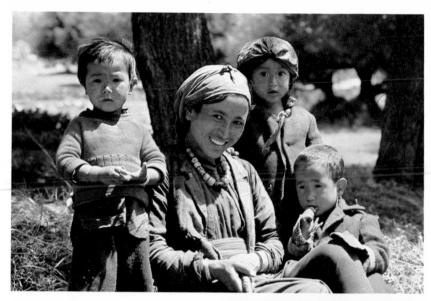

Family group
I was forced to stay in one place at 11,000 feet to become acclimatized to the altitude before going higher, during which time I got to know this family. During a break in the harvesting on the fourth afternoon the mother readily agreed to be photographed with her kids. I like the spontaneity in this snap – I took two frames on a Konica Auto.
*Fil. UV/Ekta ER64/exp. @ 125th/*JC

Father and child, Seychelles
This portrait of the brown-skinned father and his very white-skinned son is born out of the extraordinary racial mix of the Seychelles Islands. I first shot a Polaroid to give to the father, of which he was very proud.
*80mm/Ekta 40D @ 600ASA/exp. 60th @ F2 (very little light in the forest)/*JG

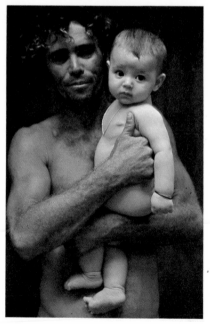

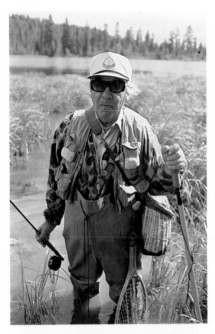

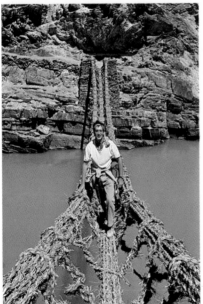

The American outdoors man
We met this old man on the road in
Arizona. I used a 35mm lens because I
wanted to work physically close to him
while still including his surroundings. He
stood in the lake especially for the picture. I
shot 30 frames and he relaxed by about
number 25. The technique of shooting a
whole roll on tense subjects can work well;
they can't remain stiff for every picture.
*35mm/fil. 81A/Ekta EPR64 @ 80ASA/morning/
exp. auto/***JG**

Bombardier, Florence
This portrait could be a detail from a 16th-
century Florentine painting. He was
leaning on his pike waiting for the
procession to move off and I only had to
attract his attention. The late afternoon
light has enriched the colour and
atmosphere.
*80–200mm zoom/fil. KR3/ED200/exp. auto/***JG**

Crossing the Indus
A great location for the photo album
portrait. These are the pictures that in
years to come will help you recall holidays
and friends.
*24mm/fil. 81A/KD64/midday light/***JC**

Portraits

Old mates, Melbourne

I came across these blokes on a walk through the back streets of Melbourne. The one on the left was already leaning on his left elbow. I asked the other to lean on his right elbow, and placed him just where I wanted him. They were obviously old mates and enjoyed being photographed together.
35–105mm zoom/fil. 81A/Ekta EPD200 @ 250ASA/exp. auto/ **JG**

Kafir Kalash girls

After several days in Bombaret, I had become a familiar sight and had gained the confidence of these two Kafir Kalash girls. I took the pictures in a peaceful spot, away from the distractions of the village.
105mm/KD64 (four rolls)/exp. 250th @ F4/tripod/ **JC**

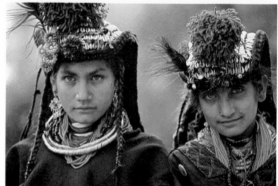

Bangladesh

Bangladesh is a portraitist's dream – if you like group portraiture, that is. Within 5 minutes of pulling your camera out of your bag you can have five hundred people posing for you – beautifully. This shot was taken from inside the car. I didn't have to pose anybody, I was a curiosity to them. To organize a composition like this anywhere else would be tough.
28mm/fil. 81A/KD64 @ 80ASA/exp. auto/ **JG**

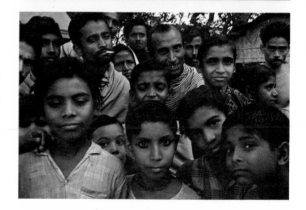

114

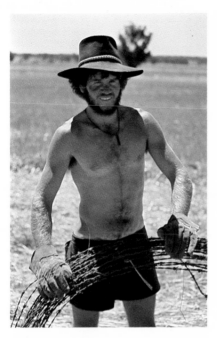

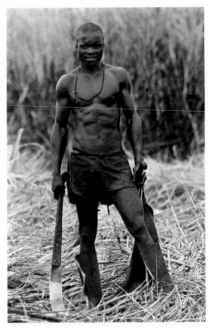

Boundary rider, NSW
These blokes live isolated lives, checking
the endless fences of the huge cattle
stations in the Australian outback.

He was therefore rather puzzled by the
figure of me trudging towards him over the
paddocks. I had spotted him from the bush
road. He was quite happy to be
photographed, but didn't stop working – it
was 108°F. He is as lean and tough as the
country he lives in. The portrait is
descriptive, not art.
*35–105mm zoom/fil. 81A/KD64/exp. auto/***JG**

Sugar-cane cutter
Having photographed this man working, I
thought I'd get a better picture by asking
him to pose for the camera, for he
epitomized and personified the sugar-cane
cutter. It is a portrait of all the men who
work through the heat of the day as well as
a picture of the man himself. Shot on a long
lens wide open so as to hold him 'off' the
background.
*180mm/KD64/exp. 500th/tripod/***JC**

Portraits

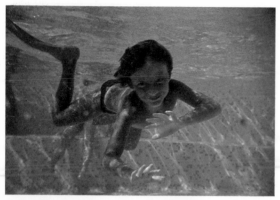

Nicholas underwater
Nicholas, my eight-year-old son, usually a reluctant model, was keen to have his sub aqua prowess recorded on film. I jumped in with my Nikonos IV and had him swim several times towards me. The camera was on auto.
*Nikonos IV/Ekta EN100 @ 125ASA/exp. auto/**JG***

Anya, Sweden
The backlight on Anya was flattering but the leafy trees in the background were a distraction when viewed through a normal lens. A 400mm lens wide open turned the trees into colour and shadowy shapes.
*400mm/fil. 10 Magenta to remove green light filtering through the trees/Ekta EPR64 @ 80 ASA/morning/exp. auto @ f3.5/tripod/**JG***

Zanskar girl
A taxi driver arranged this picture. He took me to a family who owned a headdress and a daughter to wear it! We all went up to the roof, and asked the girl to stand so that she was three-quarters back-lit by the sun. The driver held up a borrowed sheet to reflect the evening light back into the shawl, the jewellery and her beautiful face.
*85mm/fil. 81B/Ekta EPR/reflector – late afternoon light/**JC***

116

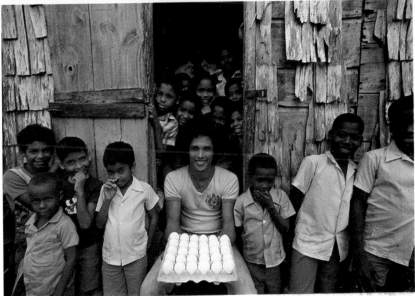

Chicken farmer, Antigua

This man is a successful chicken farmer, but his chicken coops were tumbling down and the chickens were bare-arsed and scrawny. The scene did not look promising. I sat the farmer and his tray of eggs in the doorway of the hen-house, but even the extreme 18mm lens could not make the shot sufficiently interesting. Then the local school broke for lunch and I was saved. I chatted to the children who couldn't wait to be in the picture. A tripod can be useful to free you from having to hold the camera and provides a focal point for the sitters. Forget your inhibitions and be prepared to act the clown. Pictures are not always waiting for you – sometimes they have to be created.

*18mm/no fil./Ekta ER64 @ 80ASA/exp. auto/tripod/***JG**

117

Reportage

Reportage pictures come easily on holidays when you are stimulated by the differences around you.

Speed is required to observe, focus and shoot almost instinctively for reportage photography, but don't be put off if you don't get it right first time. Your pictures will improve quickly as your technique develops. You can't read about it, you have to do it.

The checklist must become second nature to you. So many potentially good pictures are ruined by the lack of sound routine and good habits – so check and check again.

The qualities common to all good reportage photographers are: the ability to tune into the life around them, plus concentration, perseverance and anticipation. Concentration, to avoid being caught without your camera loaded, perseverance to stay on the streets when others are back resting in the hotel, and the anticipation to see a shot about to happen.

You don't need to go far to escape the tourists – a couple of blocks away from the main attractions you can be alone with the locals. Most tourists travel vast distances to look at each other. Avoid the guided tours – buy a few books and discover things for yourself.

Frenchman fishing
Shot 3 hours after crossing from England. The Frenchman, his wife and his Renault looked irresistably French. The green car on the green river bank reflected in the river made the picture graphically pleasing. For a Frenchman the situation might have been too ordinary to notice. To a tourist it is a slice of French life.
*80–200mm @ approx. 105mm/fil. 81A/Ekta EPR64 @ 80ASA/exp. auto/***JG**

Pageboys
Never pack up your cameras just because the parade has gone by. This is the time for the unusual picture. The Queen's pageboys waiting for their car personify ageless British tradition and ritual. It was raining hard; the camera was protected by a large plastic bag.
*400mm/Fuji 400 @ 800ASA/ exp. 250th @ f3.5/unipod/***JC**

119

Reportage

Moroccan showers
While photographing this pink village in Morocco I spotted the woman with the green dish out of the corner of my eye. (Probably the green caught my eye in among the pink.) This is another reflex shot – only one because she saw me and ran inside. Be prepared for the unexpected.
300mm/fil. KR3/Ekta EPD200 @ 250ASA/exp. auto but lens wide open to achieve 500th sec shutter for freezing the water/
JG

Surf Carnival, Sydney
The champs of '64. They may not look as good as they did then, but they're proud as ever. A piece of Australian tradition.
*80–200mm zoom @ 135mm approx./fil. A2/Ekta ED200 @ 250ASA/exp. auto/***JG**

Winnowing near Leh

One of the joys of travel is to go where little has changed, to see things going on that have long since died out at home. These two winnowers thought I was quite mad to stand in the middle of the flying chaff but it makes a better picture being right in there on a wide angle lens rather than standing back and photographing the whole scene. A slowish shutter has produced the streaked effect.

24mm/fil. KR1.5/Ekta EPR @ 80ASA/exp. 30th @ f16/ **JC**

Henley Regatta

There are times when you wish that you were invisible and other times when looking like a photographer results in a picture.

80–200mm zoom/mid-afternoon/exp. auto/motor drive/ **JC**

Reportage

London ball
Take a camera with you
wherever you go – even if
you're wearing evening
dress! People enjoying
themselves always make
good pictures. When you
are involved in an event
try to step back and take
an objective look at what
you are part of.
*85mm/fil. 81B/Ekta EPY/30th
@ f2/JC*

Grape picker, Cognac
You have to be thankful
for those people who love
being photographed. As
this man had to keep
unloading his basket I had
ample opportunity to
photograph him and he
was only too pleased to
oblige.
*28mm/fil. 81B (because of
rain)/Ekta EN100 @
125ASA/exp. auto @ 15th/
camera supported on edge of
trailer/JC*

Roman cleaner
Taken on a dawn walk in
Rome. This chap was just
climbing down from the
huge sculpture in the
fountain. I took several
shots but I realized that
this was the most
amusing. Often just a
portion of the scene is
more effective than the
whole.
80–200mm zoom @ approx.
180mm/no fil./Ekta ED200 @
*250ASA/exp. auto/***JG**

Lady reading magazine
A chilly day on a Spanish
beach (Alicante). I was
amused by the
juxtaposition of the lady's
face with the face on the
magazine. I made one
exposure before she
turned the page. Train
your eye to see the less
obvious pictures of people.
80–200mm zoom @ approx.
180mm/fil. A2/Ekta EPR64 @
*80ASA/exp. auto/***JG**

Reportage

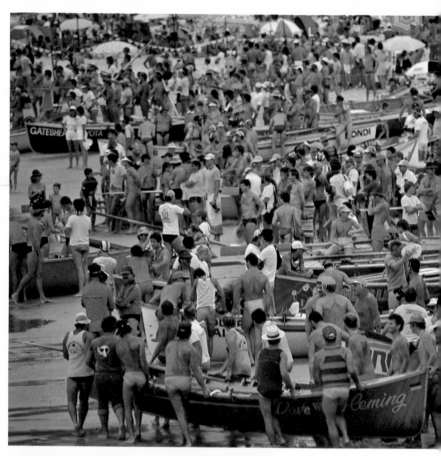

Bicycle, Stockholm
The main streets were
bustling but in this quiet
side street the only sign of
life was a bicycle waiting
patiently for its owner.
*35mm/fil. 81B/3M
1000/morning light, shade/*JC

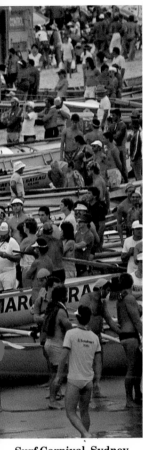

Surf Carnival, Sydney
Shot from the cliff
overlooking the
Clearwater Surf Carnival.
The 400mm lens has
foreshortened the
perspective, to give
emphasis to the crowded,
cheerful atmosphere on
the beach. Look for a good
vantage point to shoot
'busy' pictures from,
otherwise they may just
appear a mess.
400mm/fil. 81A/KD64 @
80ASA/exp. auto (no expanse
of beach here to throw out
*reading)/***JG**

Moslem women
I was sitting on the beach
of Essaouira in Morocco
when the ladies walked
past. Shot from a sitting
position with a 300mm
lens (already on camera),
when the shape of the
women and the
composition felt right. The
low angle is graphically

effective. The photograph
captures the gracefulness
of the Moroccan women –
almost like a fashion
picture. Always be
prepared for the shot that
just 'pops up' for you.
300mm/fil. KR3/Ekta ED200
@ 250ASA/exp. auto, approx.
*500th @ f4.5/***JG**

Landscape

There is a distinction between a view and a landscape. So often a view which looks majestic to the eye translates into a disappointing landscape picture. Your eye has the ability to zoom in and out, picking out the main features and unconsciously assembling a picture. The trick is to get the camera to do this too.

If you are photographing a wide or distant scene, then just using a wide angle lens to 'get it all in' does not usually work; but results in a picture which has no centre. The small 35mm format does not do the view justice. A beautiful landscape has a dominant feature as its focal point, which draws the eye's attention and also gives the picture scale. The light at a certain time of day, the weather conditions or

seasonal colours, these initially attract you to the scene and you need to be able to use these elements photographically in order to make a good picture.

The whole range of lenses is used for landscape pictures, and it is surprising how often it is a long lens rather than a wide angle that makes the successful shot. As photographers we are able to see the world around us through a long lens, something that none of the great landscape painters of the past could do. An extreme wide angle lens increases the foreground, gives big skies, and generally exaggerates any sweeping lines. You get the feeling of looking right into the picture. With a long focal length lens you either pick out a small section of

the view, using a detail that otherwise would be insignificant as your focal point, or use it to flatten the perspective, like looking through a pair of binoculars where the view looks 'squashed up'.

You have a choice of film, either fine grain to hold every detail pin sharp, or fast film to add mood.

Except for those lucky days when the lighting conditions are perfect it is important to be able to use filtration, not just to override the natural conditions, but to be able to put on film your mind's eyeview of what you see before you. Carry a snack, wear a warm coat and good boots. Be prepared to stay a long time. Your patience will be rewarded.

Zanskar, India
On my trek in the Himalayas one of the places I most wanted to see was the Buddhist retreat called Fuctal Gompa. After ten days' walk I rounded a bend in the path and there it was. I photographed it on a 24, 28 and 35mm lens but it was best through the Widelux viewfinder. No polaroid filtration was necessary, on a sunny day at this altitude the sky will appear darker, because you expose for the brighter, barren rocks.
*Widelux/Ekta EPR/mid-morning light/tripod/*JC

Landscape

Californian coastline
A view from Highway
No. 1. I used a wide angle
lens, the foreground
flowers lead the eye
towards the surf. A blue
grad. filter strengthened
the pale sky. Exposed for
the surf; everything else is
underexposed. A general
exposure would have
produced a less dramatic
landscape.
*24mm/fil. 1-stop blue grad./
Ekta ER64 @ 80ASA/exp.
auto −1/***JG**

Dacha
Before attempting the 17,500 foot Singo Pass we acclimatized by doing short climbs up the mountains. The fellow traveller gives the landscape scale. We deliberately bought a red tent and clothing because they look good in a landscape.
85mm/fil. 81A/KD64/tripod/
JC

Landscape

Zion National Park, Utah
A wide angle lens helped to emphasize the sweep of the extraordinary rock formations. The 24mm lens was stopped down to f16 to ensure sharpness from foreground to background.
*24mm/fil. A2/KD64 @ 80ASA/midmorning light/ exp. auto −½/*JG

African plains
The light isolated the single tree on the vast Kenyan plains. The tree gives the shot scale.
*300mm/KD64 @ 80ASA/exp. auto/tripod/*JG

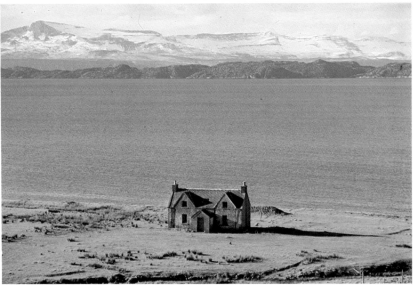

Antigua seascape
I had been searching for a shot that epitomized the blue Caribbean, and here it is. Be careful of polarizing filters in these situations: the build up of contrast can kill the subtlety of the blues.
*80–200mm zoom @ 150mm/ Ekta ER64 @ 80ASA/late morning light/exp. auto −¹/₃/***JG**

Towards Skye
A landscape seen in section. A photographer's landscape, rather than a painter's.
*300mm/fil. 81A/Ekta 64/hard morning light/exp. 15th @ f16/tripod/***JC**

Landscape

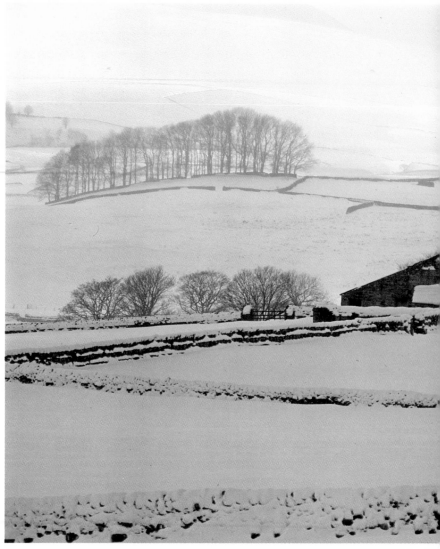

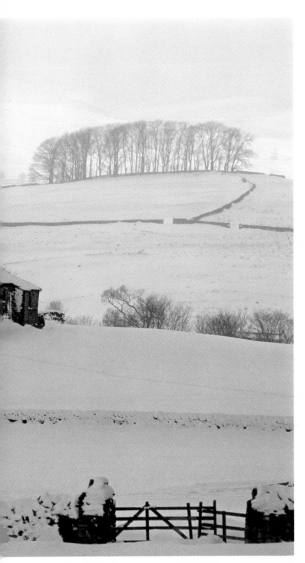

Yorkshire Dales

This is a part of Britain that I visit a lot because I love the landscape. This picture is a particular favourite because of the monochromatic colour, and the balanced composition. A long lens at f16 compacted the foreground and the background. A mile from the gate to the trees.
*180mm/fil. KR3/KD64/just before dusk/tripod/*JC

Swiss Alps

A 260° view of the Swiss Alps photographed from the restaurant on the Schilthorn. Using a panoramic head attached to the tripod and a 105mm lens, I took eight slightly overlapping pictures. For the best results, the sun should be directly opposite the centre of the area to be photographed. The exposure was set on auto to get a consistent density in all eight frames.
*105mm/Ekta EPD200/midday light/tripod (essential)/*JC

Children

Travelling with children in faraway places makes you more acceptable to the local people.

Children must have lots to occupy them on trips; maps to follow, tapes and books in the car, collecting things, pressing flowers, etc.

Encourage your child's involvement in the photography. John's boys have jobs: one always carries the tripod and one is in charge of the film.

Local children love to be photographed. There are endless possibilities for portraits, and, if you are there long enough to be ignored, reportage pictures too.

When shooting the world of the child put the subjects in a situation you know they will respond to, then back off and just record the event.

Do not scrub all the charm off the child before the shot. Take the child's own personality, not how you think he should be.

Do not insult a child's intelligence. Give firm, polite and precise instructions. Do not be wishy-washy.

Try shooting from a kneeling position – from the child's height – not always looking down on him.

Do not put the camera away too soon. Children habitually perform

Viennese pastry
The pastries of Salzburg proved irresistible to Mathew. A 28mm lens distorted the size of the cake and slightly elongated his face and mouth, making the picture into an amusing memory: the mind's eye

again. Anticipating is the key to peak action shooting – just practise. The ¾ backlight is good for both child and cake.
*28mm/fil. KR3/Ekta 200 (useful around old towns with narrow dark streets)/exp. 125th @ f4/***JG**

Girls in yellow
These girls are supporters at their school track meeting in the Seychelles. Through the 400mm lens they looked like a wall of yellow dresses and umbrellas. The long lens had the effect of bringing the background girls right up behind the foreground girls. They would have become self-conscious had I worked close-up with a short lens.
*400mm/fil. 81A/Ekta FD200 @ 250ASA/exp. 250th @ f11/***JG**

135

Children

best after the camera has been put away.

To take good photographs of children you need to master the mechanical skills – the ability to follow focus, and 'snap' focus. Practise without film on anything that moves. Practise with the zoom to frame accurately.

Never start to shoot until you are absolutely ready (extra film out of packet and in pocket). A child's concentration is short, so don't waste time messing around while the child 'cools his heels'.

Practise changing film fast. The ability to plan and anticipate is important.

Don't forget the checklist.

Zoom lenses are ideal for pictures of children (80–200mm range).

A camera with auto facility is very useful for speed and quickly changing conditions. (Must have override facility.) Motor drive is useful.

A small auto focus camera in the pocket is very useful when you can't manage a camera bag, for example on shopping expedition with small children.

Mathew's jump

Mathew, complete with flippers, was leaping over me and through the fountain of the Es Saadi Hotel, Marrakech. Nicholas passed me the Nikonos IV and I shot pictures of his shapes against the light. The auto setting was bound to produce silhouettes with all that light crashing into the meter. This is a picture symbolic of the spirit of childhood – not particularly a shot of Mathew. Underwater cameras are very useful around the pool and on beaches. Often that's all I take.

*Nikonos IV/Ekta ER64 @ 80ASA/exp. auto/***JG**

Mathew's guns

Mathew set for a showdown. I was attracted to the colour as much as the gun duel. An 80–200mm zoom allowed me to crop quickly in the camera. I shot a number of general pictures as well but this is the strongest composition. An 81B filter lifted both the green and the red.

*80–200mm zoom/fil. 81B/Ekta 64/exp. auto −1/3/***JG**

137

Children

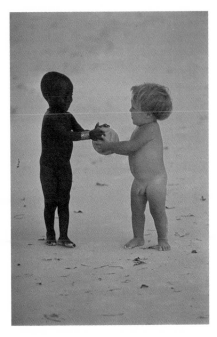

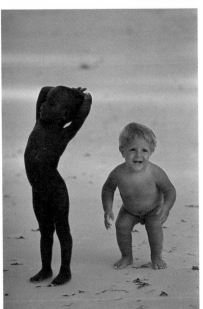

Mathew and Samadi

We were renting a house in Malindi, Kenya. Samadi was the three-year-old daughter of our cook. Mathew was also three at the time. We knew that the two of them together would produce good pictures, whatever they did. Michelle gave them the red ball to introduce a drop of colour, Mathew passed it on to Samadi and then provided the drop, or I should say stream, of magic! I had already taken a good roll of shots and was changing films. Michelle yelled out to me. I spun round and got off three reflex shots of the action – this is the best one. Without a motor drive or auto winder it would have been almost impossible. This shot resulted from the luck that often follows good planning.
*80–200mm zoom/fil. 81A/Ekta ER64 @ 80 ASA/ exp. auto/***JG**

Children

Girl with autumn leaves
School children playing in the park in London. The colour of the little girl's shirt matched the autumn leaves. Her teacher allowed me to take a picture. The backlight picking out the leaf and framing her blonde hair made the picture. I shot it from a long way off with a 400mm lens plus a 1.4 teleconverter (560mm). The long lens threw the background out of focus and the narrow angle excluded any flare from the backlight.
*400mm ×1.4 teleconverter/fil. 81A + 5R gel./Ekta ER64 @ 80ASA/exp. 500th @ f5.6, exp. for leaf/tripod/***JG**

Little girl at washing line
This little girl helped her mother with the laundry every day at my hotel in the Seychelles. She was shy, but once she got to work on her laundry, she relaxed. I framed her head between the palm trees. By adjusting the height of the line I was able to concentrate on her soulful eyes.
*35mm/fil. 81A/Ekta ER64 @ 80ASA (for blues)/exp. auto −¹/₃/***JG**

Turkish girl
A street portrait – a simple description of a typically Antalyan face. I shot from a kneeling position to be at her eye level, and used a wide open aperture to keep the background unintrusive.
*80–200mm zoom/ER64 @ 80ASA/exp. auto @ f4/***JG**

Girls, Marrakech
These girls called out for me to photograph them in the Suk in Marrakech. I turned, focused and shot instinctively. They then ran away – surprised by their own boldness. Practise turning and focusing on an object quickly.
*80–200mm zoom/fil. A2/Ekta 400 @ 800ASA/pushed ¹/₃ stop in process (low light in Suk)/***JG**

Baseballer, USA
Tread softly to look into a child's world. A baseball match on a vacant allotment in the Florida Keys. The scene was 'American' to me, the tourist. This youngster was sitting disgruntled, watching.
*80–200mm zoom @ 200mm/fil. A2/Ekta 200 @ 500ASA/***JG**

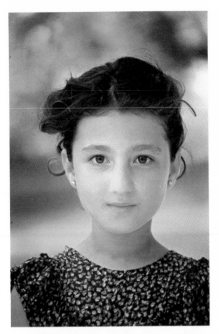

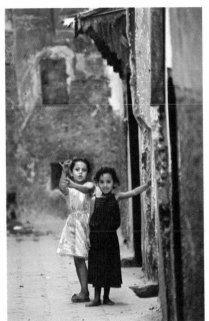

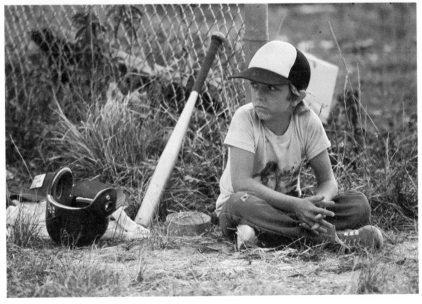

Children

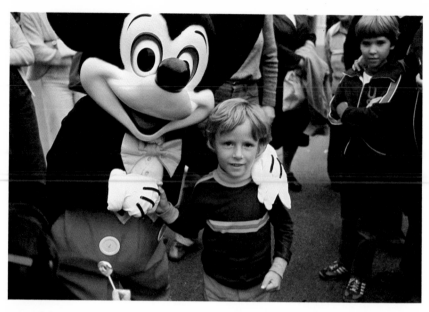

Nicholas and Mickey Mouse
Mickey and Nicholas met on our visit to Disneyland. I organized the two quickly (Mickey is a very busy mouse) and shot two frames. Typical family snapshot – a lasting memory. Shot on Nikon AF – ideal for this situation. Be precise and quick.

Mathew running on beach
Mathew 'flying' around the Devon beach in his new Captain Nimrod underwear. Lying on the beach I got him to 'fly' past me. The low angle is dynamic. Shot on Nikon AF.

Final assault
Nicholas was running at full speed, it was about to rain and very overcast. I used an 81D filter, which turned the drab colour into a strong sepia. I prefocused ahead and let him run into an empty frame.
80–200mm zoom/fil 81D/Ekta EL @ 800ASA pushed ½ stop in process/exp auto 125th @ f45/JG

Glamour

Few people have perfect bodies, however everybody looks a good deal healthier after a week's holiday. The glamour photographer's job is to make his model look at her or his best on film.

Getting dressed up for the evening is a perfect opportunity to take a glamorous portrait. Using your hotel room as a studio, you will both be more relaxed: being photographed shouldn't be an ordeal.

Pre-planning is very important. You should select clothes and accessories that will blend well with your surroundings. It is important to study the mechanics of the body; be aware of what happens to the bust line when the arms are raised, the back arched, or the legs placed in different positions. Being aware of this will enable you to pose your model to best advantage. Inspiration may be gained by looking through relevant magazines, such as *Playboy*, as other photographers' pictures will spark off your own imagination.

Once on holiday wait until the second week before shooting. By this

Girl on steps
The location looked so good – the steps were freshly painted and the light was perfect: it just had to be used for a picture. The regular sharp steps contrast well with the curving stretched figure. The angle of the steps forced her to arch her back and narrowed her waist.
*135mm/fil. KR1.5/KD25/midday light/tripod/*JC

time your model will be suntanned and everyone relaxed. During the first week look for locations. We have found the independence that a car gives you indispensable for this. When shooting, remember that clothes can be used to hide blemishes, high heels make legs look longer and props can give the picture added interest. The 81 series of filters warm up skin tones and the no. 2 Softar filter with the lens stopped down smoothes out skin blemishes. Always shoot on a tripod, as this helps develop an awareness of any potential fault in your model or in the surroundings.

In nude photography light is the important element. Train yourself to think of the body as a series of round smooth curves. Use sympathetic light to emphasize the good features and shadowlight to hide the not so good. In glamour and nude photography warm, late afternoon light, windowlight and soft, cool pre-dawn light are the most flattering. Direct hard light should be used only if the subject has a very good body or on well-posed portions of the body.

Nude

This nude was shot by windowlight on a dull overcast day. I chose a 3M 1000ASA film for its grainy 'painterly' quality. Shot on an 85mm lens with a no. 1 Softar and an 81EF filter attached. Stopped down to f11 the Softar filter becomes a 'cosmetic' rather than a soft filter. In combination with the 81EF it smoothes out any skin blemishes and gives a glowing 'suntan' effect.
*85mm/fil. no 1 Softar + 81EF/3M 1000 @ 1500ASA/exp. 60th @ f11/**JG***

Clare

The light from a handflash is hard and direct, bounced flash is much more glamorous, the bigger the light source the better the light. if you need more reflectors white sheets and towels are handy. The Cokin diffuser filters are good for smoothing out the skin and making highlights glow.
*85mm/fil. KR1.5, no 1 diffuser/Fuji 100D/exp. @ f8/3 flash units/tripod/**JC***

Glamour

Girl and waterfall, Shimba Hills, Kenya
With all the black rocks, there was a
danger of overexposing Carolyn. This is an
ideal situation for a spotmeter facility on
camera. I chose a 60th of a second so that
the water would blur and look soft. I got
Carolyn to straighten her back and pull in
her stomach, which showed off her figure at
its best.
*80–200mm zoom @ 120mm/fil. A2/Ekta EL400 @
500ASA/exp. 60th @ f5.6/tripod/*JG

Dunes
There is a time in the day when the light is
perfect for skin tones – the last 45 minutes
when the sun is low and zaps straight at
you. Fuerteventura is very windy, and
although wind is usually a hindrance (it's
always difficult to see it in a picture) I
thought I could make use of it here. I
bought six metres of cloth in town. The
flowing colour contrasts with the sharpness
of the sand and sky. Just a simple prop has
made the picture.
*180mm/Fuji 50D/late evening light/exp. 500th/
tripod/*JC

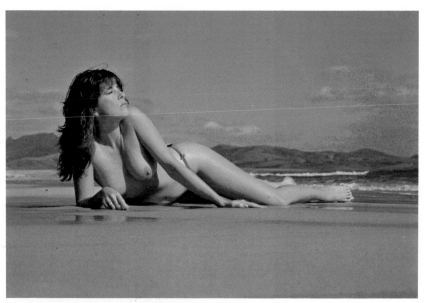

Beach

Lying on warm sand in the sun, with gentle cooling waves lapping around you is a lot of people's idea of bliss. It also makes a good glamour picture. The position of the arms hides any creases and the 35mm lens stretches the body. The camera was on the ground, so Ruth's head appeared high in the frame.

*35mm/fil. 81B/Fuji 100D/ midday light/top viewer/***JC**

Miguel, Argentina

Miguel was photographed by windowlight – perfect for strong definition on the male torso. Used without a soft focus filter here – more masculine. He posed himself, I only moved him around for better lighting.

*85mm/fil. KR3/Ekta ER64 @ 80ASA/exp. auto −¹/₃/***JG**

147

Capturing the action

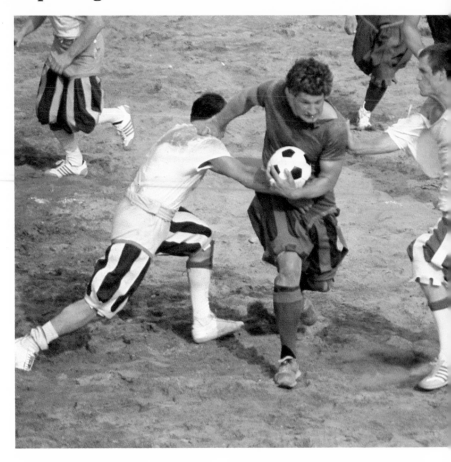

At sporting events there are usually areas set aside for professional sports photographers, which is very nice for the photographers but the pictures all look alike. Many times I have looked enviously at a seat in the stand that would be a perfect camera position for the event. All the pictures on the following pages have been chosen because they were shot from the stands with no special privileges allowed.

Sport attracts photographers for its intense human drama – triumph, despair, joy, anticipation, tension.

The trigger finger has to be on the move before the action peaks – if you see it in the camera it is too late, you can only try to anticipate and practice.

It helps to know the game that you're shooting. Practise following focus on moving subjects. Watch out for that great 'off-screen' picture, such as the anguish of the loser. If shooting from the stands, anticipate the passage of the sun throughout the day – try to sit in the west stand. The new generation 200 and 400ASA films are ideal for action photography. Remember, like the sports that you are shooting, practice makes perfect.

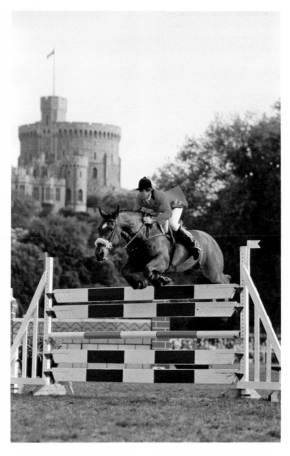

Calcio Storico, Florence
This picture captures the action and violence of this extraordinary football game which has been played in Florence since the 16th century. There is no attempt at graphic design or art here.
*300mm/fil. A2/Ekta EPD200 @ 250ASA/exp. auto, approx. 500th @ f4.5/***JG**

Windsor Horse Show
This was all about getting into position before the event started. I wanted the jump with the castle in the background. Fortunately the sun was in the right position! While the spectators were at tea, I was able to get the seat I wanted. A lot of sports, including showjumping, are repetitive so you have plenty of time to familiarize yourself with the action. This sort of picture is easier to do shooting one frame and using the motor drive as a winder rather than a blast with the motor. There is no guarantee that 4 or 6 frames a second will capture the precise moment of peak action whereas the trained eye can.
*135mm/KD64/exp. shutter priority @ 500th sec/***JC**

Capturing the action

Cowdrey Park, polo
Polo is a fast and furious
game played on a large
pitch. To get right into it
you need to use a long lens.
Here at Cowdrey Park the
1000mm lens was
mounted on a unipod and
the camera set on auto.
Panning with a long lens
is not difficult, but holding
focus on a moving subject
with a long lens needs
practice.
*1000mm/Ekta EPD200 @
360ASA/motor drive used in
bursts at about 125/200th/
unipod/**JC***

Bowlers, Australia
Saturday afternoon at
Doncaster Bowling Club
in Melbourne. They're not
as athletic as they were 30
years ago but they're just
as competitive and
enthusiastic as ever. I sat
the camera on my camera
bag and removed the
prism from the F3 and I
shot when the composition
of the bowlers was
pleasing.
*300mm/fil. 81A/Ekta EPR64
@ 80ASA/exp. auto/**JG***

 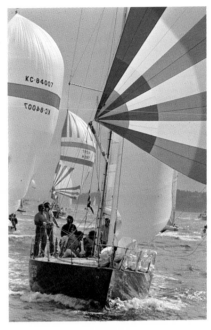

Athletics, Seychelles
A school track meet in the Seychelles. This picture captures the human emotion of sport rather than the action. Prefocused on the tape, I kept both eyes open to see who was going to win.
400mm ×1.4 teleconverter/fil. 81A/Ekta EPD200 @ 250ASA/exp. auto/ **JG**

The Fastnet Race, Cowes
I have photographed sailing from two different types of boat: firstly, in a fast Avon rubber inflatable with high splash boards, and secondly, from a three-deck launch, rather like a Merlin fishing boat. Both have advantages. In a high-speed Avon you can get yourself into the ideal position, photograph and be away quickly. The major problem is sea spray: however much care you take things get wet. From a launch you have to have a skipper who is able to respond to your every request to get in position and then hold it. But the cameras remain dry and you can also shoot with a long lens. Use two headbands to stop the camera hitting your forehead as the launch tosses about. It is always difficult to hold the horizon level.
180mm/fil. 81A/Ekta EPR @ 500ASA/exp. auto/ **JC**

Safari

There are two types of safari holiday – the smart lodge type, and camps. Lodges are expensive but not necessarily the best for photography – too smart, too social. We have found the camps to be more sympatico, and just as comfortable and safe as any hotel even though you are in amongst the animals.

It is difficult to take good animal pictures without a good animal guide and a four-wheel drive jeep or Land Rover. It is well worth the money to hire both. Guides are always very helpful when they see that you are keen. Try to avoid sharing your vehicle with other people – they move around too much, causing camera shake, and they inevitably want to move on when you want to stay. It is much better to stay in one or two places and wait for the animals rather than chase them all over Africa.

Having four-wheel drive will keep you out of trouble and give you the freedom to go almost anywhere; to get a better angle for your shot, or move into the right place for the sun. The majority of animals are active in the morning and late afternoon when there is little light around, so you need to shoot more fast ASA film than you would imagine.

It is wise to remember that you are in the wild, not an exotic zoo or game park; so do not corner the animals. Don't bait them by being too persistent with the camera: it is astonishing how quick and powerful they can be if they attack. Animal photography is a fascinating subject, for no matter how much experience you gain in the field you will never be in control. Don't be disappointed if you don't come back with great wildlife pictures. Professionals spend their whole lives only rarely getting a stunning shot. Everyone needs patience. You are in the hands, paws and hoofs of your subjects.

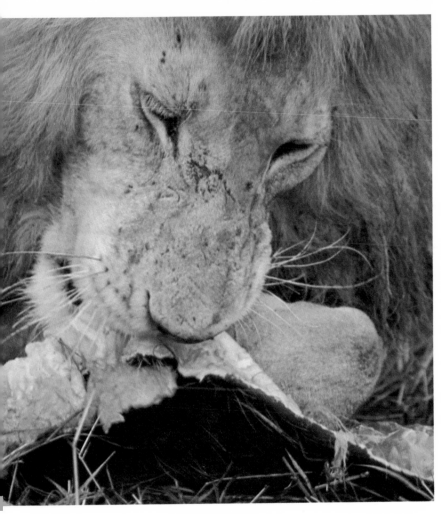

Lion, Kenya

We were staying under canvas at Governor's Camp in the Masai Mara because they have very fine animal guides. We were lucky to have John, a terrific bloke who can spot a lion from a mile away. John had seen a pride of lions earlier in the day – they had not yet made a kill. We located them by 5.30 p.m., and as John had predicted they were enjoying their dinner. I sat my camera on the bean bag on the roof of the Toyota four-wheeler (it has a sliding roof). I shot on several lenses taking the whole pride and individuals. This shot is on a 400mm with a 1.4 converter taking it to 560mm. A very interesting fact about tele lenses is that later you see things in the picture that were not obvious at the time.

24mm/EL400 @ 800ASA pushed ⅔ stop in process/exp. bracketed/JG

Wildlife

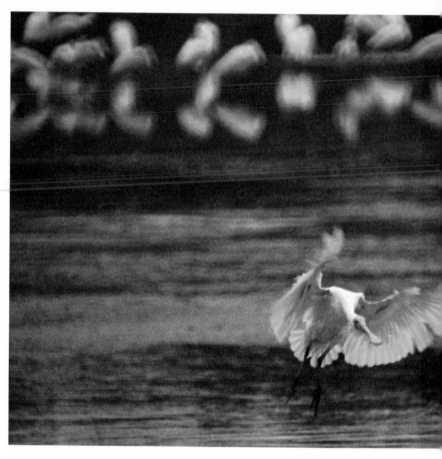

Spoonbill, Everglades, Florida
I decided on this location the night before and arrived at the water by 6.30 a.m. I pre-focused on a part of the lake where there was a lot of activity within range of my 500mm mirror lens. Photographing birds in flight is very difficult unless you can find such an area, or a nest or tree where they habitually sit and from where you know they will eventually take off. I missed focus on about 20 shots before I got this one. I shot on a tripod with the locks loosened off, so it was just a steady hand, as it were. A motor is very useful when photographing birds because it allows you to keep your eye on the finder and concentrate on focus and composition.

*500mm mirror/no fil., I liked the grey light for the pink bird/ Ekta 400 @ 800ASA/exp. auto −¹/₂, 500th @ f8/**JG***

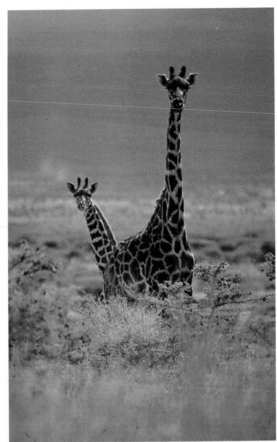

Two-headed giraffe, Tanzania

This very rare two-headed giraffe was discovered in Tanzania. We were camping in the bush at the time when it suddenly raised its heads above the trees. I always keep a 300mm lens on a camera when on safari. I grabbed it and shot quickly before it loped off (large head first). Don't be disappointed if you can't spot a two-headed giraffe on safari, they're very rare!

*300mm/fil. 81A/Ekta EPR @ 80ASA/exp. 500th @ f4.5/*JG

Wildlife

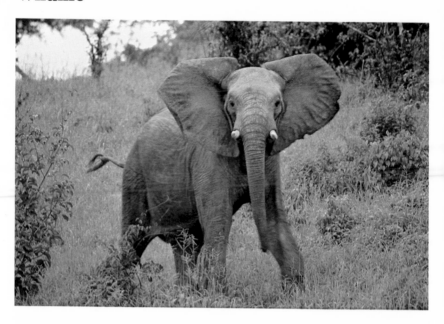

Elephant, Ruhara Game Park, Tanzania
In mid-afternoon the warden and I were watching elephants enjoying the river. The Land Rover was between the bush and the river and this elephant just came through the undergrowth right in front of us.
*180mm/fil. 81C, to make the dusty greens richer/motordrive/sitting in Land Rover/***JC**

Baby seal, Orkney
The mother seal was away, so I could get reasonably close to the baby. Crouched low to be at its level and to cause it the minimum of distress.
*105mm/fil. 81A/Ekta EPR64/***JC**

Peacock, Holland Park, London
Springtime. I was just wandering with one camera, an 80–200mm zoom and a 35–105mm zoom and a few rolls of film. This peacock was displaying himself for his hen to admire. The 80–200mm zoom is perfect for this type of shot. The peacock was separated from me by a fence, but I was able (even from my fixed position) to frame very accurately so as to use the peacock to make a pattern.
*80–200mm zoom/fil. 81A/Ekta EPR64 @ 80ASA/exp. auto/***JG**

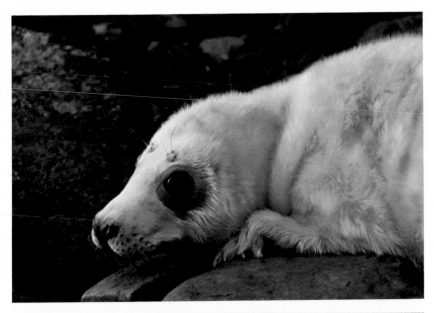

Wildlife

Walrus, Marine Land, San Diego
This portrait of the walrus was taken during feeding time. I stood next to the keeper and was able to take my time and focus carefully on the old boy so as to get every whisker sharp. This session came to an abrupt end when the walrus spat about a litre of filthy water all over me and the camera! Zoo keepers are proud of their animals and are usually very helpful with tips for a good shot that can save you a lot of time. Watch out for walrus keepers, however, they are inclined to withhold vital information!
*80–200mm zoom @ 180mm/fil. A2/Ekta EPR64 @ 80ASA/exp. auto/***JG**

Heifer
Coming down off the hills at sunset I had to walk through a herd of heifers. Normally I wouldn't have bothered to take any pictures, but as so often, the light inspired me to take this one.
*85mm/fil. 81B/Fuji 100D/exp. auto, camera meter handled this exposure very well/***JC**

Architecture

Many of the top architectural photographers were themselves once architects. To make good pictures of buildings you have to appreciate them, and see how they express the history, culture and spirit of a people. It is an emotional experience to see the world's great buildings for the first time – whether it's the skyscrapers on 6th Avenue, the first winter snow on St Basil's or dawn breaking over St Peter's.

If you have only a limited amount of time to photograph a building it's worth spending seventy per cent of it on reconnaissance and thirty per cent taking pictures. Don't just look at the building from close up – move away to see how it relates to its environment.

If you're not in a hurry, watch to see how the sun lights it so that you can choose the best time of day.

All your photographic equipment can be useful for pictures of buildings. The tripod is essential; filtration isn't, as long as the light is good. There's no single lens which is particularly suited for architecture, but a 28PC does help if you are in a city with narrow streets and can't get far enough back to frame the whole building. A slow fine-grained film should be used to get lots of detail. Architecture is not only about grand buildings, it's just as big a challenge to take a careful and revealing picture of the most humble shack.

La Défense
This building epitomizes modern office architecture – clean, sharp-edged structures soaring into the sky.
35mm/Fuji 50D/exp. @ f16, for maximum sharpness/**JC**

The interior of l'Opera
A complete contrast is the picture opposite: the interior is sumptuous and ornate. A central camera position emphasizes the architectural symmetry and the extreme wide angle lens has exaggerated the sweeping lines. A long exposure had to be used so that the people walking up and down the steps wouldn't register.
15mm/no fil./Ekta EPY/exp. 45 sec @ f22, auto but bracketed by changing the ASA dial as well as the +1 and +2 settings/tripod/**JC**

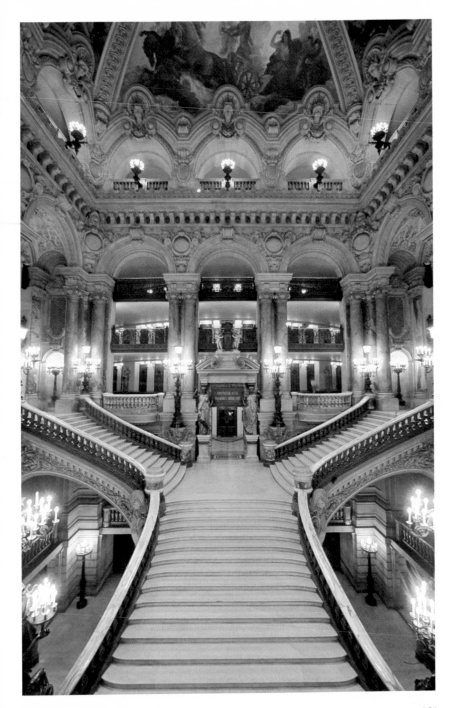

Architecture

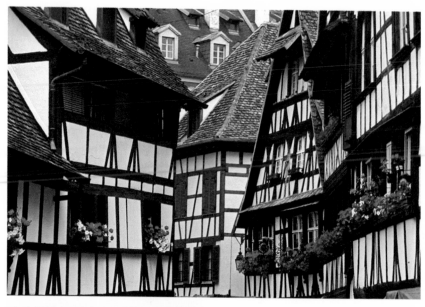

Strasbourg, France
This shot was tightly cropped to emphasize
the detail in the Elizabethan-style
architecture of Strasbourg. Shot on
80–200mm lens @ 180mm. The telephoto
has had the effect of compressing the
houses together. The light was dull but the
windowboxes provide enough colour to lift
the picture.
*80–200mm zoom @ 180mm/fil. A2/Ekta EPD200
@ 250ASA/exp. 125th @ f8/***JG**

French mill
In its romantic setting this house near
Ornans, France, looks like a lovely place to
live. I saw it in the morning, but returned
in the afternoon when the sun and
reflections were better.
*180mm/fil. KR3/Ekta EPR/afternoon light/
tripod/***JC**

Arabian detail, Sharjah (UAE)
A window detail, typical of the beautiful symmetry of Islamic architecture.
*80–200mm zoom @ 150mm/no fil./Ekta EPD200 @ 250ASA/exp. auto approx. 250th @ f8/**JG***

Tower, Morocco
Sundown in Marrakech – a symbol of Morocco. The sun had set, leaving a red glow. I sat the camera on my camera bag. I used an 85mm lens and 3M 1000ASA film pushed to 2000ASA, and a KR6 filter to strengthen the red glow.
*85mm/fil. KR6/3M 1000 @ 2000ASA/exp. auto −½ stop on override, 8th @ f5.6 (enough to hold trees sharp)/**JG***

Architecture

The National Theatre, London
The architect who designed the National Theatre wanted people to glimpse bits of London through its strong vertical and horizontal lines. A tight composition reinforces this.

*85mm/no fil./Ekta EPY ('wrong' film, but blueness hides the stained concrete)/exp. f16/tripod/**JC***

Harrods
One of the traditional sights of winter London is Harrods looking like a fairy palace. Shot from a position that allowed me to get most of the building in frame, avoiding intrusive street lights.

Photographed on daylight film while there was still some light in the sky, although the main light was tungsten. The warm result is the colour of Harrods.

*135mm/no fil./KD64/exp. 8th @ f16/tripod/**JC***

Bath

A lucky picture because I was there in these unusual light conditions. The late sun lit up Lansdowne Crescent so that it stood out from the thundery sky. Exposing for the highlights has exaggerated this, and a wide angle lens has stretched the sweep.
*35mm/no fil./KD64/tripod/***JC**

Colonial House, Barbados

This beautiful little house is typical of the British West Indies. The owner graciously agreed to be in the picture. Shot on a 24mm lens to enhance the sweep of the stairs, plus a polarizing filter used to darken the blue sky.
*24mm/fil. polar./Ekta EPR64 @ 80ASA/exp. normal on camera meter/***JG**

Paris

The symmetry of the design can be appreciated because it was photographed with a PC lens. To stop a building falling over backwards either move away and come in with a long lens, or use a PC. If you have to use an ordinary wide angle find a position from which you don't have to look up.
*28PC/fil. polar./KD25/hard morning light/tripod/***JC**

Cities

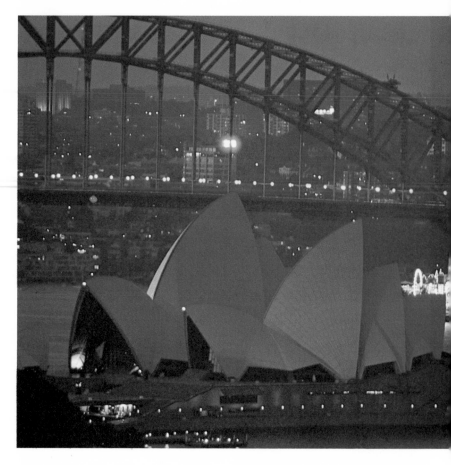

All cities have their own unique views: New York from Staten Island ferry; London with the Thames and the Houses of Parliament; Paris with the Eiffel Tower and Rome the Coliseum. They are the symbols of these cities. Buy the postcards, because they are a useful guide, but before you go to take a similar shot, work out your own ideas of how to use the symbols. This may only mean getting up really early to photograph the same view as the postcard: your picture will be quite different.

Try to make contact with 'city' people, the vendor, waitress, cabbies and cops, the people who live on the streets and really know their city and can point the way to the *real* photographs of their town – not the postcard pictures.

The city is not only the wide view, it is also the detail. Look for the unexpected out of the way shot that captures the flavour of the town. We love 'street-walking'. Wandering around a city just taking pictures is one of life's most enjoyable experiences.

Use the guide books written for the discriminating traveller, which will take you to the less well-known sights. And don't try to cover too much in a day: plan a few pictures and leave the rest to chance.

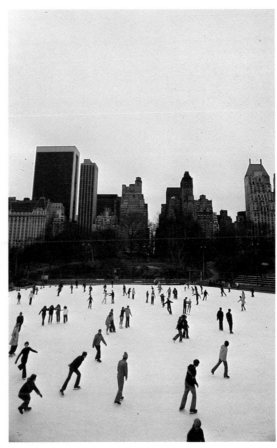

Sydney Harbour
This picture could only
have been made in Sydney
– the Opera House and the
Harbour Bridge are its
greatest landmarks. I shot
the picture from the roof of
my hotel (after
consultation with the
manager) in the late
twilight. Luna Park, a
huge brilliantly lit
funfair, made an obvious
focal point. This shot was
planned, it didn't just
happen.
400mm/no fil./Ekta EL400 @
500ASA/exp. bracketed,
*approx. 8th @ f5.6/tripod/***JG**

New York
Central Park ice rink on a
bleak winter's day. Don't
put the camera away
when the conditions seem
less than ideal. This
monochromatic view of
New York, dotted with
colour from the skaters'
sweaters, made an
unusual and effective
picture. The 20mm lens
stretched the perspective
which gives a slightly
surreal atmosphere.
20mm/fil. 81A/Ekta EPR64 @
*80ASA/exp. auto/***JG**

167

Cities

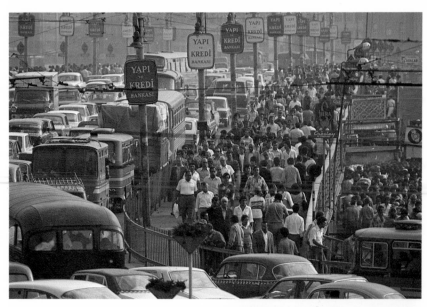

Traffic jam on the Galata Bridge, Istanbul
One million people cross Istanbul's Galata Bridge every day. This picture was shot at 8.15 a.m. when Istanbul is going to work. I shot with a 300mm lens from the steps of the nearby mosque. The telephoto effect makes the most of the crowds and traffic jams of an Istanbul morning.
*300mm/no fil./KD64 @ 80ASA/exp. 125th @ f5.6/tripod/*JG

Istanbul
Another view of the Galata Bridge from a mile away, worked out roughly with my map in the hotel. I searched for the camera position several hours before sunset and waited. Birds appear in several shots but this one which echoes the shape of the mosque is luck – the kind of luck we all deserve after a lot of hard graft. The trick is to get yourself into the right place before time. Both shots are typically Istanbul – one is looking at the inside life of the city, the other at its physical beauty.
*500mm ×2 teleconverter/Ekta EL400 @ 500ASA/ exp. bracketed/tripod/*JG

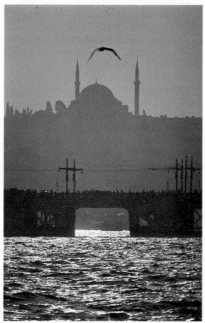

Degas poster, Paris
Photographed whilst wandering around the Marais quarter of Paris. An obvious picture because of the ground level position of the poster and the light. Just waited for a black-clad figure to fill the gap to 'add life'.
*85mm/fil. KR1.5/Fuji 400/***JC**

Stockholm
The alleyways of old Stockholm were peaceful in the early morning light but it was too blue and too cold. I wanted it warmer, a light more sympathetic to the yellow plaster, more like afternoon light so I used strong filtration.
*180mm/fil. KR12/KD25/exp. 8th @ f22/tripod/***JC**

Monuments

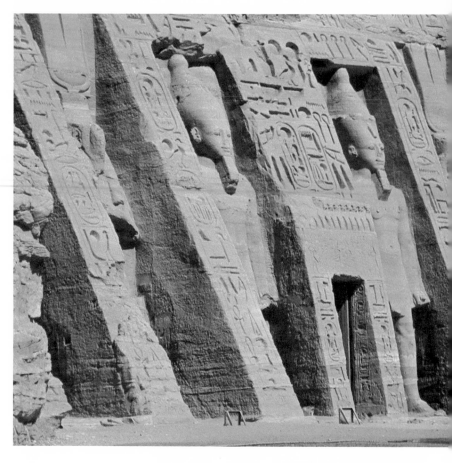

This is one occasion when you could easily be in the right place at the wrong time. Monuments, museums and ancient buildings all survive because a lot of people want to see them. The serious photographer should avoid the organized excursion wherever possible as it is too rushed and there are too many people making money out of it: the bus company, the restaurant, the gift shop, etc. These people don't really care whether you get more than a snap.

The majority of tours to the world's monuments coincide with lunch – totally the wrong time to see the Pyramids, Taj Mahal, Olympia, the Col-iseum, Abu Simbel, etc. Try to go on your own at the best photographic time of the day. The tour guides and hotel staff are usually quite happy to organize something for the serious traveller.

But as well as the world famous sites, don't miss out on the less well-known monuments. Check out the noticeboard in your lobby to discover what country houses, museums, ruins, etc. are nearby. Again, if you can make your own way there, your pictures of these places may well catch the spirit of the country far better than any cli-chéd postcard view.

Abu Simbel, Egypt
I had to go quite a long way off to photograph the seated colossus of Ramses II. When I had finished, I turned round and found myself in the perfect position to photograph the Temple of Queen Nofretari. The keeper has brought the picture to life. I used an 81EF filter as this was shot in colourless midday light, so the colour of the stone had to be 'put back'.
*180mm/fil. 81EF/Ekta ER64/ tripod/***JC**

Princess Cecily
Princess Cecily, third daughter of Edward IV, from the Royal Window of Canterbury Cathedral, now housed in the Burrell Collection in Glasgow.

Enlightened museums now illuminate stained glass with daylight-corrected tubes which photograph quite true to colour. I always photograph the information plaque alongside the picture as well so there is no problem with captioning.
*55mm macro/fil. 81A/KD64/ exp. at f2.8 (did not need my depth of focus), average exposure reading/handheld/***JC**

Still life

A still life can say as much about a place as any other kind of picture. We have to be like the old painters who had to rely on natural light falling on everyday objects.

A tripod is essential, because you have to compose the still life painstakingly through the viewfinder. Try to see the objects simply as shapes with volume, colour and texture. Remember that the space between the objects and the frame is as important to the composition as the objects themselves.

Keep the composition simple. Make sure there is no unwanted rubbish in the frame; use the preview button. Bracket your exposure and you will get interesting results you did not expect. Carry a reflector so you can control the light. Use film and filtration that is sympathetic to the subject.

Still life photography can be very therapeutic; it makes a refreshing change from the usual rushing around. The old pros say that if you can take a good still life and a good portrait you can do anything!

Still life, Greece
I bought the pot in a typical tourist shop; there were dozens of them. It was in the car for a week before I found the right coloured plasterwork on a small church. There were plenty of marigolds in the village, the gardener was amused about why I wanted them!

200mm macro/fil. KR6/(enhancing the colour of the light plasterwork and flowers)/3M 1000/late afternoon light/tripod for framing rather than stability/ JC

Bottles, Venice
This was taken while lunching in a restaurant in Venice. I moved myself around until the shapes of the bottles looked right against the background shapes. I used a 35–105mm zoom and cropped it in the camera.

Really look for details.
35–105mm zoom @ 90mm/fil. 81A/Ekta EPD 200 @ 250ASA/exp. auto – ½/tripod/ JG

172

Fish dish, Istanbul

I looked at my meal from every angle, but it was best from right over the top. The right side of the picture was too dark, so I hung my white napkin over the chair to 'fill in' the dark area. The background is only an old plastic tablecloth. Remember to keep it simple: when a shot looks too simple it is probably just right.

*55mm macro/no fil./KD64 @ 80ASA/exp. auto/*JG

Almonds, Martha's Vineyard

Re-constructed after a dinner at a friend's house. Hand flash, bounced off the opposite wall. Reflector in front of camera. ¼ second exposure to allow some room light to register.

*55mm macro/fil. 85B both on lens and flash (to balance with the room light)/KD64/tripod/*JC

Cards, Istanbul

In the *chai* (tea) houses in Istanbul the men play cards or backgammon. I shot on a 55mm macro because I needed to be close and wanted the well-used cards and the hands very sharp. I used the preview button to check that the background was unsharp, I didn't want any distracting detail, only a red background. When the hands were in a good position I asked the guy to hold still.

*55mm macro/fil. A2/KD 64 @ 80ASA/exp. bracketed/tripod/*JG

Close-up

Close-up photography shouldn't be regarded as a specialized subject requiring studios, expensive equipment and knowledge. In fact, any travelling photographer can use it to add another dimension to his pictures.

There are four practical ways to enter the world of the close-up. First, there are zoom lenses with micro settings, which focus closer than a fixed focal length lens. Secondly, there are micro lenses, which are designed for close-up photography but also double as a normal lens. Thirdly, you can carry a close up filter which enables a lens to focus closer than it was designed to do; and finally there are auto-extension rings which, when placed between the camera and the lens, dramatically change the lens's ability to focus really close so that a bumble bee will fill the viewfinder.

The world of micro photography – photographing the hairs on the bee's legs – is too specialized for most travelling photographers.

When the lens is focused really close, there is little depth of field. To hold everything sharp, the lens has to be stopped right down. At f22 you will

need a lot of light, more than daylight, so the only solution is to use flash. New TTL flash metering has made close up photography much easier and reliable. The exposure is calculated by the amount of light actually on the film. Use the flash off the camera with a reflector so the light moulds the subject, and even though you are in close use the tele setting as this channels the flash. If you are planning to take close-ups don't forget the tripod. They are difficult handheld.

Money
A collection of coins from all over the world. The hard light of the flash has picked out the base relief of the heads and lettering. Most everyday objects look quite different when photographed really close up.
*55mm macro ring/Fuji 50D/tripod/***JC**

Peacock feather
Found in a hotel garden in Sri Lanka and set on a table mat. Shot on 55mm macro lens. Lit by a hand flash held next to the lens. If you take this kind of picture indoors you have much greater control over the result.
*55mm macro/no fil./KD64 @ 80ASA/exp. auto/ tripod/***JG**

Close-up

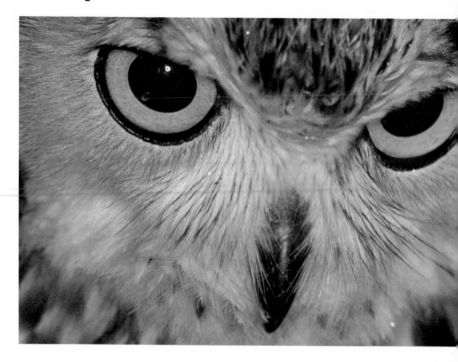

Owl
Photographed in a bird
sanctuary. The owl was
quite tame but I let him
approach me rather than
the other way round. The
ring flash was used
because its hard direct
light would get right into
the tiny feathers. Be
careful of 'red-eye' when
using this flash; it is more
suitable for inanimate
objects. Its advantage in
close-up photography is in
getting the light source
very close to the subject,
and there are no shadows.
*200mm macro/fil. 81A/KD64/
ringflash/unipod/***JC**

Coffee beans, Ivory Coast

The obvious picture was to photograph the coffee bean pickers with their round baskets on their heads. This I did, but then I looked at the other possibilities. Back on the light box I preferred this picture – the colours, the texture of both the beans and the hands. Coming in closer is always a good idea. I used a reflector to 'push' more light into the beans. Photographed in midday light at a temperature of 140°F. My can of 'Dust-Off' was hissing alarmingly and had to be discarded in case it exploded!

*35–105mm zoom macro/KD25/midday sun/ exp. @ f22/even in these bright conditions I used a tripod to get a maximum F no./***JC**

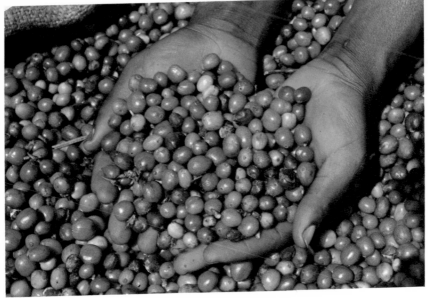

Detail

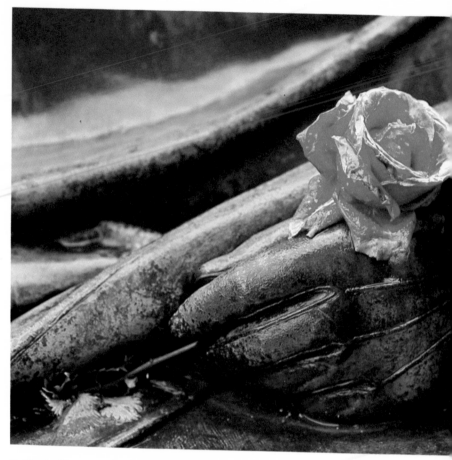

Rather than take a picture of the whole scene consider taking just a detail and letting that tell the story – it is concise but it also leaves something to the imagination. Several details of the same subject tell more about it than one picture of the whole thing.

Père Lachaise Cemetery, Paris
Woke up to a miserable grey, wet morning, the sort of day that is not encouraging for pictures. At the top of the hill is the recumbent figure of Victor Noire. His fame was limited in life but in death he is widely known. Some admirer has placed a rose in his hand, now dying, just as he died a hundred years ago in a wet Paris street. The detail seemed to sum it up well.
*85mm/fil. 81A/KD64/exp. bracketed/tripod/***JC**

Virgin Atlantic's 747
The first rays of dawn just caught the rim of the engine and in this case it looked even better on film.

Auto focus cameras in this situation focus on the window, therefore the engines, etc. will be unsharp. To avoid reflections from inside the plane look through the window with a blanket or jacket over your head.
*35–105mm zoom/fil. 81A/3M 1000/sunrise/exp. auto @ f8/***JC**

Detail

Peppers

The peppers appeared to be almost jumping off the old wooden trays. I shot with a 24mm lens so as to leave lots of space around the peppers because it is the dark bluish grey of the background that really accentuates their vivid colour – the red netting leads the eye down to the peppers. When shooting colour, try to think of the subjects as coloured shapes.

*24mm/Ekta EPR64 @ 80ASA/exp. auto −1/2 to exaggerate strength of colour/***JG**

Hands, Botswana

In the doorway of her house in Gaberone, a mother was standing with her twins. She was happy to be photographed, but the twins hid behind her skirts. However, their hands holding on to hers made a lovely picture. Don't give up when the picture that you go after doesn't come off. You can often find a fresher alternative.

*80–200mm zoom @ 150mm/Ekta EPR64 @ 80ASA/exp. auto −1/3/***JG**

Clogs, Amsterdam
The hands carving in an Amsterdam market made a strong composition against the dark blue shirt. The little clog of his toggle played off well against the real ones. The 35–105mm zoom is ideal for these situations when you are elbow-to-elbow with hundreds of tourists, it enables you to frame from a fixed position.

*35–105mm zoom @ 65mm/fil. A2/Ekta EPD200 @ 250ASA/exp. auto – the camera is exposing normal for white clogs so the rest goes dark/***JG**

Roots, Central African Republic
We were entering the tropical rain forest of the Congo Basin and pulled off the road for lunch. There was little undergrowth but very tall trees with extraordinary root systems. Photographed this and the whole tree as well but this shot is more exotic and jungly.

*35mm/fil. 81A/KD64/midday haze light/exp. f11/***JC**

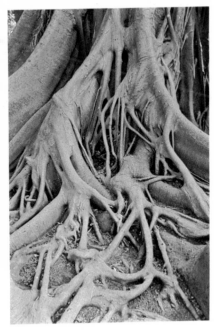

Detail

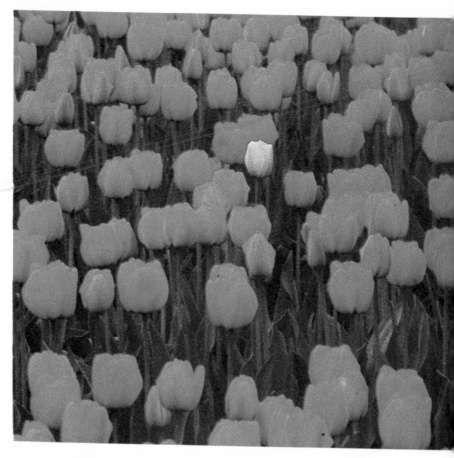

Yellow tulip, Amsterdam
Spring in Holland. I spotted one lonely yellow tulip in a great field of red ones and shot on 3M 1000 film – chosen for its painterly qualities (there was enough light for fast film). The 300mm lens ×1.4 teleconverter has the effect of compacting the tulips together.
*300mm lens ×1.4 teleconverter/fil. KR3/3M 1000 @ 1500ASA/exp. auto/***JG**

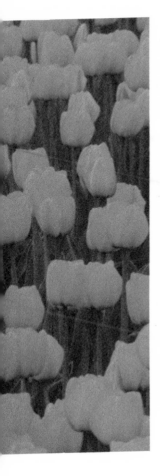

Cephalonia, Greece
The roads on the island have been cut into the hills all along the coast, so from high up you get a spectacular view of the secluded beaches. This picture was taken on the second visit: I'd chosen the colour of the umbrella deliberately to contrast with the blue sea. I kept the figure small, because on holiday most people want a beach and a patch of sea to themselves!
*135mm/fil. KR1.5/KD64/ midday July light/tripod/***JC**

Framing

Modern viewfinders have one major problem: the fine focus circle and centre weighted metering seduces you into composing with the subject in the middle. There are so many other ways to use the format, adding a dynamic interest to the picture. The main image occupies a space in the frame, but the space around it is just as important.

Fountains Abbey, Yorkshire
By using an arch or doorway to frame your
subject you give the picture depth. Choose
the right time of day so that the archway is
a strong shape and expose for the subject.
Note: a dark frame may influence an
automatic exposure reading.
*28PC (to stop tower leaning backwards)/Fuji
100D/late afternoon light/exp. f16/tripod/***JC**

Ship, Corfu
This framing seemed logical. I was
attracted to the beautiful range of blues. I
needed the ship as a focal point.
*80–200mm zoom @ 200mm/no fil./Ekta ER64 @
80ASA/exp. auto/***JG**

Framing

Masai, Kenya
I wanted the warrior to be large in the frame but still give a feeling of the plains that he was crossing. This framing on a 500mm lens has solved the problem. He has space to stride across and the composition is graphically dynamic – the negative space between the warrior and the edge of the frame is pleasing.

500mm/fil. 81A/Ekta ED200 @ 250ASA/exp. auto/camera supported on bean bag on car door/ **JG**

Henley Regatta, England
I had seen the blue and white tent and also the people in candy striped blazers, and my intention was to put the two together. I got into a position where the blue and white was framed as I wanted, then waited 20 minutes for the 'victim'. Three frames with the motor drive and I had a picture. The bonus was that he was carrying a programme.
35–105mm/fil. 81A/KD64/motor drive on auto/ **JC**

Pink brush on brown wall, Venice
The floor brush was already against the brown wall. I amused myself for 5 minutes composing the shapes that the shadows made on the wall. There are interesting pictures to be made of the most mundane objects if you can forget what they are and think of them just as shapes and colours.
28mm/fil. KR3/Ekta EPR64 @ 80ASA/exp. auto −2/3 stop/ **JG**

Priest, Crete
The strong positive shapes of the priest's black hat and cassock combine simply but strongly with the negative white shapes between the priest and the edge of the frame. Shot in shade light, the background is nearly white because it is about 5 stops overexposed.
105mm/fil. A2/Ekta EPR64 @ 80ASA/exp. auto/ **JG**

Ritual

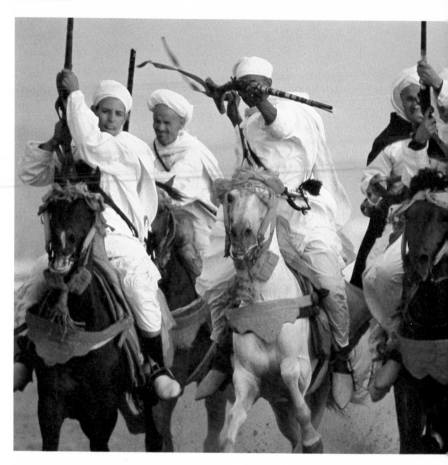

Festivals, ceremonies and rituals, from war dances in New Guinea to barn dances in Oklahoma, offer great opportunities for exciting, colourful pictures which will capture the essence of a place.

Do your homework in advance, so that you know exactly what's going to happen and can choose a position with a good view. A high camera angle is usually best. Don't, however, preconceive your pictures. Try picking out individual participants – often more telling than a general view. Be prepared to take advantage of an unexpected magic moment.

Fantasia, Morocco
This is one of the Moroccans' favourite festivals – a brilliant display of precision horsemanship. We were sitting on the beach when we heard rifle shots. Suddenly one hundred Moroccan warriors came galloping down the beach, guns ablaze. I scrambled into position and shot on a 300mm lens + ×1.4 teleconverter. I focused in front of the horsemen and shot when they came into

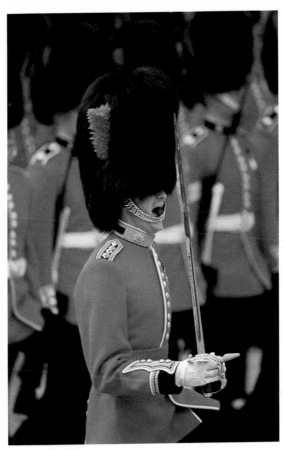

focus – it's the only way to get them sharp. These guys scared us all to death, but it was worth it.
*300mm ×1.4 teleconverter/ Ekta 400 @ 800ASA pushed ⅓-stop in processing/exp. auto/motor drive/***JG**

Trooping the Colour
Rather than photographing the moving 'red squares' of soldiers, I wanted to see their individual faces and expressions. I had to shoot from a fixed position so I was forced to use a 600mm lens. The red jackets and black bearskins would have confused the camera meter. I took the readings with a spot meter off their faces before I started shooting.
*600mm/Ekta EN100/exp. auto, clip tested when processed/tripod/***JC**

Markets

Themes
Themes evolve naturally in the work of most travel photographers over the years. One becomes fascinated by comparing markets, roads, street signs and doorways from one part of the world with another. Having a few themes to look out for concentrates the mind, especially when you are having one of those 'what shall I photograph days?'

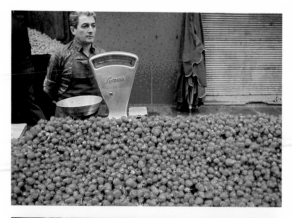

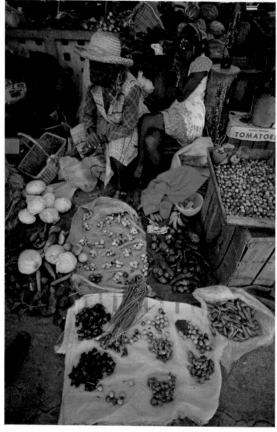

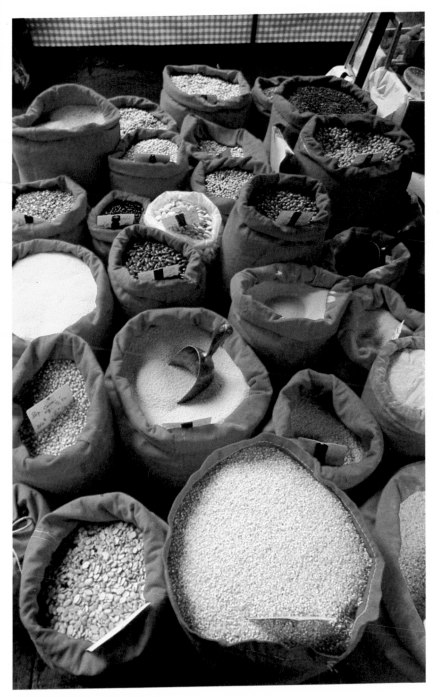

Photographers

National costume

Sunsets

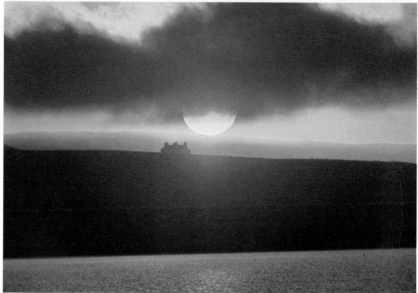

Palm trees, Florida
I looked for a foreground frame for the sun. A ball of sun without any other feature could be anywhere.
*80–200mm zoom @ 100mm/fil. A2/Ekta ER64 @ 80ASA/exp. auto + ½ stop/***JG**

Orkney
Photographed from a moving boat, the camera was mounted on a unipod resting on my foot to absorb some of the vibration.
*500mm/Ekta 200/exp. bracketed on auto + 1 and 2 stops 250th +/***JC**

Clouds, Tasmania
The sunset reflected on the clouds was more interesting than the sun itself, especially when shot with the 18mm lens.
*18mm/no fil./Ekta ER64 @ 80ASA/exp. auto −1/3 stop/***JG**

Silhouettes, Sri Lanka
The afterglow of sunset, often the most spectacular colour. The 24mm lens distorts the silhouettes for graphic effect.
*24mm/fil. A2/Ekta ER64 @ 80ASA/exp. auto + 1/3 stop/***JG**

197

Camera effects

Once you have mastered the basic principles of photography and know what all the buttons and dials do on your various pieces of equipment, you can experiment with them and achieve all sorts of effects. Whatever effect you apply to a picture, it should enhance it rather than just be a gimmicky demonstration of what a particular piece of equipment can do.

Most holiday pictures are taken because of the subject matter. But sometimes it is more satisfying to create a picture of your own rather than just shoot what is in front of you. Apply your photographic knowledge and come up with an idea for a different type of picture.

Lincoln Cathedral
This is a double exposure, but not done in the conventional way. The rising full moon was photographed at 6.30 p.m. I shot a whole roll, altering the position of the moon in the viewfinder every six frames.
Rewound the film, but not off the take up spool.
Drove 120 miles to Lincoln and re-shot the film.
*400mm (both pictures)/fil. A2/3M1000/tripod (both)/*JC

Tivoli Pagoda, Copenhagen

The park is a mass of sparkling light at night: the buildings are made from light bulbs. This picture was made by applying the properties of the 35–105mm zoom lens; I used the tripod and made several trial runs. First I framed the pagoda on the 35mm setting, then pulled the zoom to the 105mm setting during a long exposure, which streaked the light.

Set the camera meter on auto and take the reading with the subject filling the frame (105mm setting) – go for the longest practical exposure. (Here it was 8 seconds.) Then reframe on the 35mm setting, keeping the subject right in the middle. Time the exposure, do nothing for 4 seconds, then pull the zoom slowly for the next 4.
*35–105mm/fil. KR1.5/KD64/ tripod/*JC

West End, London

Lights and reflections make good pictures. This is a multi-exposure shot – 7 separate exposures. Used a marker to draw in the ground glass after each shot so that I had an idea of how it was building up. Expose only for the highlights.
*35–105mm/Ekta EN100/spot meter/tripod/*JC

Black and white

Masai warriors, Tanzania

The young men were in the middle of nowhere. I shot a portrait of them in colour and black and white, but the black and white is a much more satisfying picture. It seems to be somehow ageless, strong and dignified. The colour by comparison seems almost flashy. I used an orange filter to hold tone in the blue sky. Be generous with exposure on black and white when using orange or red filters – + ⅓ stop for orange, + ⅔ for red – otherwise you will retain no shadow detail.

*35mm/fil. orange/Ilford HP5/exp. auto +⅓/***JG**

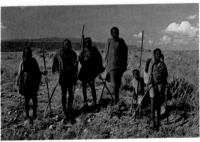

Many photographers who are committed to photography as art consider black and white to be the only pure form of expression, believing that colour seduces the eye away from the true content of the picture. Certainly black and white offers a far greater opportunity to control the result; in fact, we believe there's no point shooting black and white unless you wish to get involved in developing and printing your own films. There is no greater thrill in photography than watching a really good print appear magically in the developing dish.

Nowadays even small towns have evening classes in developing and printing. This is an ideal way to pick up the fundamentals from which you can develop your own technique and style at home.

The skill of black and white photography is that of reading colours in terms of grey tones. To help you understand how colours transpose into black and white, switch the picture on your TV screen repeatedly from colour to black and white. This is a useful guide. Filters are used in black and white to achieve greater separation between the tones. In black and white a filter will lighten the colours at its own end of the spectrum and darken the colours at the other end of the spectrum. For example, a red filter makes a blue sky appear darker (doing the same job as the polarizer in colour), and a red house lighter.

The most commonly used filters are orange and red, for skies and landscapes, polarizers to cut reflection, and grads to darken areas, without altering the contrast of the rest of the picture.

It is very difficult to shoot colour and black and white together. Best to concentrate on one or the other on any single shoot.

Black and white

School, Mombasa
When shooting black and white, content is the most important consideration. The story is the most important aspect of this picture: it documents how children in a Kenyan school are taught arithmetic. I feel that colour would have distracted from this.
*24mm/no fil./Ilford HP5/exp. auto/***JG**

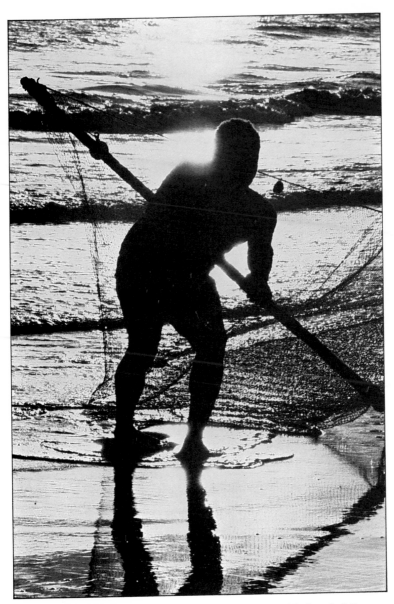

Fisherman, Sri Lanka
Dawn on the beach. This shot is made for black and white, with the strong lines of the sea and the powerful silhouette of the fisherman and his net. I had to 'print in' the sea in the darkroom later. This control in the darkroom makes black and white a very satisfying medium to work in. Try to see everything in tones of grey – not colours. I used a red filter to increase the contrast between highlights and shadow.
*80–200mm zoom @ 180mm/Ilford HP5/exp. auto + ²/₃/***JG**

Black and white

Kenyan sky
A red filter has turned the
blue sky black and made
the white clouds appear
even whiter. Cinema
camera men call this
technique 'Day for Night'
and used it extensively in
the old black and white
cowboy movies to achieve
the effect of darkness
when it was technically
impossible to shoot at
night.
*24mm/fil. red/Ilford HP5/exp.
+½/dev. Microphem/***JG**

Dunes in Fuerteventura
The dominant features in
many black and white
landscapes are the tones
and textures of nature. If
you think texture in the
same sort of way as you
think colour, then the
black and white type of
pictures won't pass you by.
I carry 24 exposure rolls of
black and white film. I use
it all on one picture and
then go back to colour.
*24mm/fil. pink grad./Agfa
25/tripod/***JC**

Filters for use with black and white films in daylight:

Subject	Effect	Filter
Blue sky	Natural	No 8 yellow
	Darkened	No 15 orange
	Dark	No 25 red
	Dark sky	Red or pink grad
	Almost black	No 29 deep red
	Day for night	No 25 red + polarizing
Seascape with blue sky	Natural	No 8 yellow
	Dark water	No 15 orange
Sunsets	Natural	No 8 yellow or none
	Increased contrast	No 15 orange or No 25 red
	Dark sky, detail in ground	Red or pink grad
Distant landscapes	Natural	No 8 yellow
	Haze reduction	No 15 orange
	Greater reduction of haze	No 25 red or No 29 deep red
Prominent foliage	Natural	No 8 yellow or No 11 yellow-green
	Light	No 58 green
Outdoor portraiture	Natural	No 11 yellow-green
Sky background		No 8 yellow or polarizing
Flowers and foliage	Natural	No 8 yellow or No 11 yellow-green
Red and orange colours	Lighten for greater detail	No 25 red
Dark blue and purple	Lighten for greater detail	None or No 47 blue
Plant foliage	Lighten for greater detail	No 58 green
Stone, wood, sand, snow, etc. in sunlight, blue sky	Natural	No 8 yellow
	Increased texture	No 15 orange or No 25 red
Architecture	Cleans up tones	Polaroid + yellow
Portraits	Keeps skin tones clean	Red
Infra-red film		Red filter

Black and white

Village children, Srinagar
Another taxi driver helped with this picture. I asked him if anything special was going on around Srinagar. There was, so we drove to his village to see a little festival honouring a local saint. Watched and photographed a Kashmiri version of ring-a-ring-a-roses, boys wrestling, and general merriment. Without any difficulty I organized an informal group portrait of the taxi driver's young relations. Shot on black and white, as the light had gone flat.
*105mm/Tri-X processed in/Rodinal/***JC**

Shell from Seychelles

I often collect things on holidays and then photograph them later at home – they often seem more special in isolation.

I shot a series of pictures of this shell, placing it on the floor near a window. A white reflector was used to bounce the window light back into the shell. Photographing simple objects like this in black and white is a fine way to learn shape, tone and light.

*105mm macro/no fil./Ilford HP5/exp. bracketed/tripod/ dev. ID11/**JG***

Black and white

Royal Exchange, London
Black and white for this picture because of the strong shapes and lines of the contrasting architecture. Went as far away as possible from the picture and then came in on it, packing all the buildings up together so the graphics of the picture were strong.
135mm/fil. 10 yellow/Tri-X processed in Rodinal/tripod/
JC

Self portrait, Hyde Park
A snap really – they looked so sweet posing away in the middle of the park that I couldn't resist a shot. I have wondered since how *their* picture turned out – I hope it wasn't all feet and grass. This picture relies purely on the content for its appeal. Colour couldn't have added anything.
50mm/Ilford HP5/dev. Microphen/
JG

Accessories

Motor drives

The F3 with the MD4 motor drive and powered by rechargeable NCD batteries is capable of 6 frames per second; with disposable alkaline batteries 4 frames a second. The NCD batteries really do upgrade the performance of the motor drive: when it's used just as a winder the film zips on to the next frame and it rewinds just as fast as it winds on. Many a picture has been saved because we have managed to reload quickly.

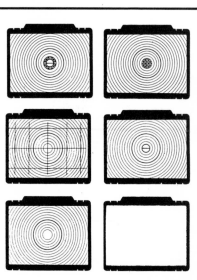

The FA with the MD15 motor drive is powered by alkaline batteries. Lighter than the MD4 – something to be thankful for after a long day! It shoots about 3 frames a second, or it can be used just to wind on, but can't rewind.

The balance of the camera is improved by attaching a motor drive and should be considered if you want to go on safari or take reportage pictures.

Straps

Don't skimp on this important item. Avoid those that adjust and leave the buckle digging into your neck. They should be wide, for comfort and non-slip. Check that the rings, rivets and clips are quality steel.

Focusing screens for Nikon F3
These are the most useful for the travelling photographer:

Type K
Fresnel glass and split image

Type J
Fresnel glass and split image

Type E
Fresnel glass + etched lines
Architectural and multiple exposure

Type A
Fresnel glass and split image

Type B
Fresnel glass

Type D
Fine matte fresnel glass
telephoto + close up

Gossen flash + daylight meter

The camera meter is capable of a lot, so why use a hand meter?

A hand meter will:
1 take an incident light reading, measuring the amount of light from the light source, as opposed to the light reflected from the subject, which is what the camera meter measures;
2 take a flash reading – especially if more than two flashes are being used (TTL metering only works if all the heads are linked to the camera);
3 calculate the exposure build up of multiple flash;
4 calculate the exposure from a mixed light source, e.g. windowlight and room light;
5 calculate very long exposures of half an hour or more.

Pentax spot meter

1° angle of acceptance, so you can take a reading off the smallest area of light in the picture.

With these two meters you have total control of exposure.

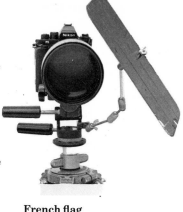

French flag

Borrowed from the movie business. A bendy arm enables you to shield the lens from the sun or a bright light that's shining directly into the front of the lens. The lens hoods on long lenses aren't long enough.

Rubber lens hood

Preferred by us simply because they pack away smaller than the metal ones.

Reflectors, closed and expanded

Two types for the traveller:
1 The space blanket foil pack. Silver on one side and gold on the other. Four bits of Blu-tack are enough to attach it to anything and it fits beautifully into the side pocket of the camera bag.
2 Expandable hoop. This is a must if you are travelling to places with hard midday light. Use it either to bounce the flash off or to reflect light into a dark area.

Accessories

Nikon panorama head
See mountainscape on pages 132-3. The only way to take good multi-picture panoramas. Shoot with camera on auto for even exposure.

Cable release
An essential accessory. Buy the type that locks, so the shutter stays open when set on B. For minimal camera shake lock the mirror up too.

Motor drive cable release
Used when you and the camera can't be together – for example wildlife photography or other dangerous occasions. Comes in 100 foot lengths. Hasselblad cable is the best.

Carrier bag
Undoubtedly the cheapest accessory you will ever need – a supermarket carrier bag with the bottom cut out, so it's a tube – protects camera from the rain.

Nikon infra-red control
Used for similar reasons as the cable release. It is possible to set the camera up before the event, then trigger off, like changing TV channels, during the event. Range is: 100–300 feet.

Secondary flash slave unit
Useful gadget – a vacuum sucker that can be attached to a shiny surface, a hot shoe for the flash head and a very sensitive photo cell that is triggered by your main flash.

Freezer pack
In the Kodak bag this will keep film, etc. cool in the hottest temperatures.

Silica gel
Silica gel packs will keep camera equipment free from moisture in high humidity.

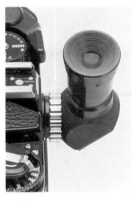

Right angle viewer
Used with cameras that have a fixed meter head. We use it on the FE when it is mounted at ground level or at an awkward viewing angle.

Filter pouch
A safe way to carry six 52mm or 72mm filters. Three packs fit in the front pocket of a Lowe Pro Magnum bag.

Nikon DW3
Used on the F3, one of the few modern cameras with interchangeable heads. This is a most useful little gadget for discreet pictures – you can shoot from waist level.

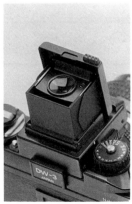

Spirit level
For landscapes, when you want the horizon level, or when using the perspective control lens, for architecture.

Household bits

These are the ordinary everyday household objects we pack for our travels. On occasions they have averted a disaster for us and on others they've been responsible for a successful shot.

Washable lens cloth *Not* the impregnated type.

Lens cleaning fluid The only way to get rid of fine dust from lenses.

Stiff brush For cleaning around the camera.

Solid fuel handwarmer For warming the fingers.

Jeweller's screwdriver Check screws are OK after long plane journeys or jolting drives.

Small compact mirror For reflecting light into close-up pictures.

WD 40 Use to clean the tripod and equipment if it has been near sea spray.

Torch For cleaning or working in the dark.

Compass To know where the sun will be.

Elasticated strap with hooks So many uses.

Sewing kit In 5-star hotels they are supplied free!

Universal electric plug.

Stuff sacks For spare film or doubling as a bean bag.

Vaseline and cotton buds For cleaning cameras and tripod. Vaseline for making soft or star filters.

Blu-tack For sticking gel filters to the rear element of a mirror.

Strong clips One with a hot shoe adaptor.

Gaffa tape For emergency repairs.

Strap with self-locking buckle For when you need a really solid attachment, e.g. unipod to fence.

Glue The type you mix because it is stronger and safer.

Swiss army knife One with 18 blades, it has a thousand uses!

Fold-up bag For filling with stones and hanging from the base of the tripod to make it more stable.

Space blanket A good light reflector.

Pens The permanent type.

Notebook For captions.

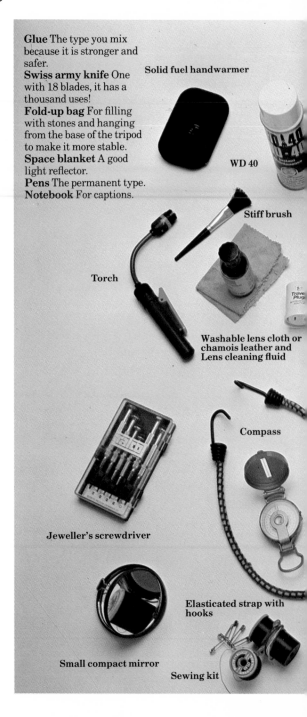

Solid fuel handwarmer

WD 40

Stiff brush

Torch

Washable lens cloth or chamois leather and Lens cleaning fluid

Jeweller's screwdriver

Compass

Elasticated strap with hooks

Small compact mirror

Sewing kit

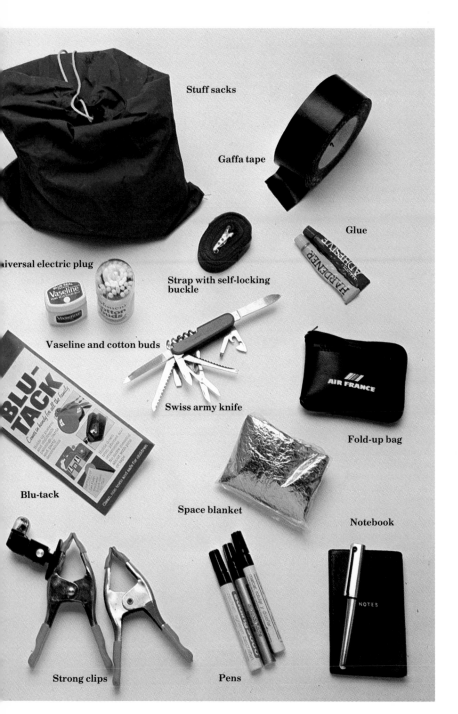

Stuff sacks

Gaffa tape

Glue

Universal electric plug

Strap with self-locking buckle

Vaseline and cotton buds

Swiss army knife

Fold-up bag

Blu-tack

Space blanket

Notebook

Strong clips

Pens

Tripods

Some people regard tripods as an optional extra. We disagree. For us a tripod is a vital part of the travelling photographer's kit. It has many virtues. It is a great aid to composition.

A tripod is essential to steady a long lens, even on fast shutter speeds. A tripod is also useful when you are experimenting with filters – it leaves both hands free to change the filters. A tripod is valuable when you are taking portraits; it is a constant reference for the sitter.

Remember, a cheaper camera on a tripod will give you better results than an expensive one in shaky hands.

Large Gitzo With Manfroto head. Very steady for very long heavy lenses but too large and heavy for travel.

Medium Gitzo Will comfortably support most long lenses. A tripod we take on travel assignments.

Leitz Tiltall Lightweight but sturdy. A good travel tripod.

Small Gitzo Best small tripod on the market. Low height useful. Will fit in a suitcase.

Gitzo Monopod Useful just to steady a long lens. Much used by sports and news photographers.

Linhof clamp Useful for awkward positions. Used for remote cameras.

Bean bag Any bag filled with beans or something similar, very useful for shooting out of car windows.

Leitz table top The tripod to use when you don't want to carry a tripod.

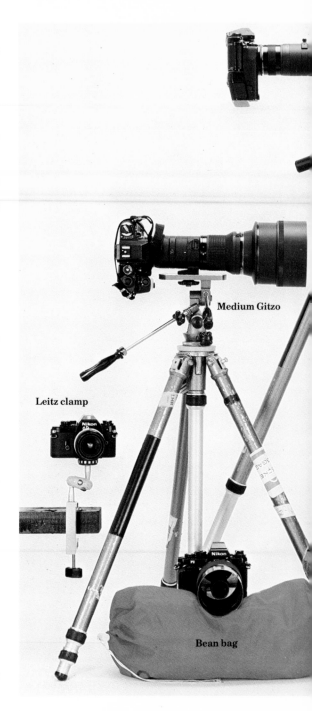

Medium Gitzo

Leitz clamp

Bean bag

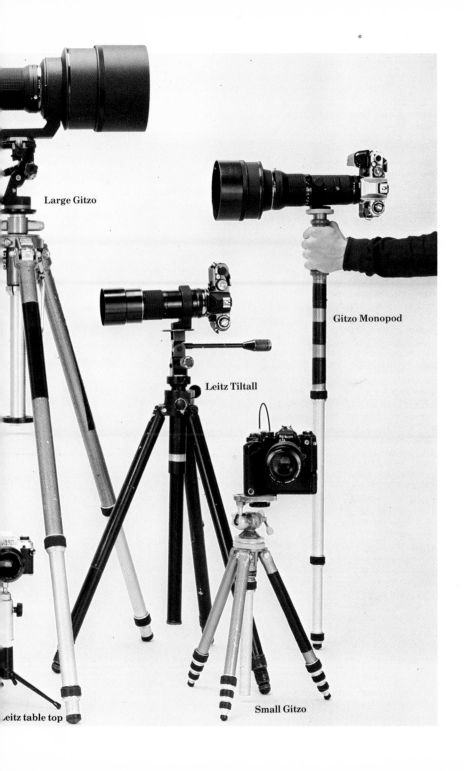

Large Gitzo

Gitzo Monopod

Leitz Tiltall

Leitz table top

Small Gitzo

Camera bags

Don't skimp on your camera bag: it is a vital piece of equipment. Not only does it protect your cameras, it can make your photography more pleasurable.

Choosing the right bag can be difficult because you don't know how good a bag is until you have thoroughly used it. Illustrated are the types that we both have.

A metal case should be lockable and strong enough to check in as hold baggage when you are travelling by air. Some countries won't allow hand-baggage on internal flights. If you choose a soft bag make sure it is the right size for the amount of equipment you have. It should open wide, have a solid base, pockets, 'grab' handles that secure the bag and a non-slip shoulder strap. It should be a clean, neat design that moulds itself to your body and closes firmly so you can run with it or work in crowds without causing an obstruction and without fear of your equipment being stolen. The inside should be as well-designed as the outside, with a place for everything. Make sure that you get to know exactly where every piece of equipment lives: you should be able to work in the dark. Always empty each day's rubbish out at night and repack for tomorrow. Don't let taxi drivers, hotel porters or any stranger handle your bag. A good bag is as important to you as a good travelling companion, and they are hard to find.

Pelican Strong, plastic moulded. Waterproof and dustproof.

Zero Halliburton Strong and light. The rounded corners are kind to cars and furniture.

Billingham 330 The best medium-sized bag around. Two main sections. Grab handles to carry even when the bag is open. Fine British craftsmanship.

Lowe Pro Elite Useful for long days around town.

Billingham Pouch Good for trekking and safaris.

Billingham tripod bag Besides tripod it will take umbrella, light stand, and waterproof clothing.

Kodak film bag Ideal for hot and cold conditions, and on the beach.

Tamrac Pro Takes as much as you can comfortably carry.

Lowe Pro with rain cover A plastic bin liner will do the same job in an emergency.

Lowe Pro Many photographers all-time favourite.

Billingham A tried and tested bag. Still very popular. Used also as a film and accessories bag. Takes 400mm f3.5 with body.

Zero Halliburton (open) Foam filled and cut out to fit lenses. Affords good protection.

Lens pouches Can be attached to rucksack or packed inside.

Chamois leather Wrapped round lenses, keeps them cool and clean.

Lowe Pro Omega I 'bum bag' For skiing or when a shoulder bag is impractical.

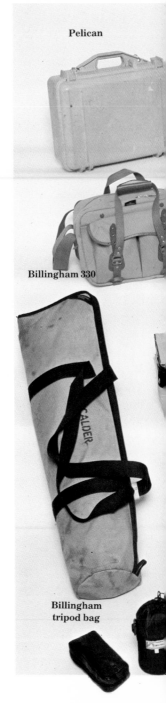

Pelican

Billingham 330

Billingham tripod bag

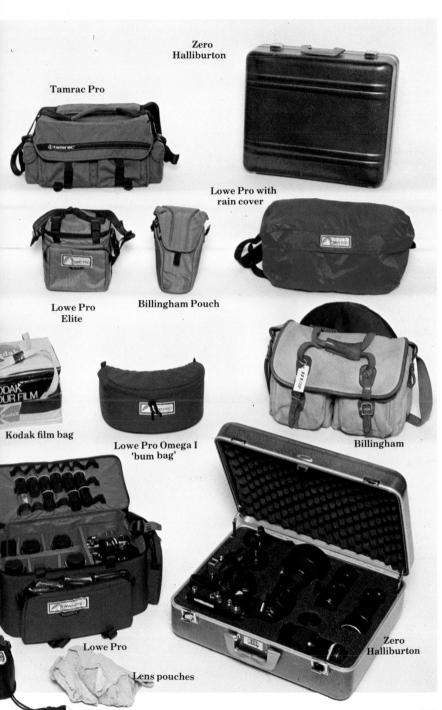

Zero
Halliburton

Tamrac Pro

Lowe Pro with
rain cover

Lowe Pro
Elite

Billingham Pouch

Kodak film bag

Lowe Pro Omega I
'bum bag'

Billingham

Lowe Pro

Lens pouches

Zero
Halliburton

Clothing

Good pictures come from good planning and preparation. So as well as taking care of the camera equipment, remember to look after yourself as well. Being comfortable, no matter what the conditions, makes it easier to take pictures – sometimes it would be impossible if you weren't properly dressed. Choose clothes that are comfortable and practical, rather than smart: for instance, training shoes may not be the height of fashion, but they are secure on almost any surface. There are times when it is necessary to blend in with the background, but at other times olive green battledress is the last thing you should wear!

For hot countries, cotton is the best fabric, but for cold and extreme cold conditions manmade fibres are the best. We take the minimum amount of clothing, once you are there you never seem to want to wear as much as you thought!

Richard Carey – Rock climber
Fanny Dubes – Photographer
These are the sort of clothes to wear when out and about taking pictures in hot dry conditions; everything cotton and nothing too tight.

You do need to wear a hat if you are going to be walking around all day in the sun, especially if you are not used to it.

Shirts should have collars so the camera straps don't cut into a sunburnt neck. Breast pockets are safer, less likely to get 'picked' than back trouser pockets.

Shorts: made by Tenson. Comfortable, strong with good pockets.

Geoff McKeown – Trekker
Dressed for the bush, scrub, hills or anywhere off the beaten track. Shirt with large breast pockets, long sleeves – nice to have option of wearing them rolled up or down. Ex-army, Rohan or Fjall Raven trousers, extra strong seams and thigh pockets. Canvas gaiters allowing you to trek through brambles and bracken, and preventing stones from entering your boots. Karrimoor's KSB3 or Berghaus Sprite boots made of suede and Gortex with a good general purpose sole. This type of boot dries out very well; a good summer walking boot. Also an easier boot to break in, don't wait until your holiday to do this!

Fanny Dubes

Richard Care

**Steven Satow –
Jungle driver**
No fashion designer has
yet come up with a smart
outfit for the jungle.
Therefore let the US Army
kit you out because they
have spent millions
getting it right. Cotton
hat, scarf (to stop things
going down your neck),
long-sleeved shirt
buttoned to the wrist,
loose trousers with ankle
draw-strings, cotton socks
and US Army jungle
boots. You are dressing to
prevent bugs and creatures
biting too much of you.
Mosquitos can nip through
jeans, which is why
clothing should be loose.

**Jo Higgins –
Trekker**
Rain, wet weather pack
made by North Face. The
jacket and trousers pack
up into their own pockets.
I keep them in a 'bum bag'
in the car, there is nothing
more annoying than
getting soaking wet trying
to find a place to shelter.
There is nothing one can
do about wet feet!

Clothing tips
Put a string loop through
all zip pulls. Easier for
cold or gloved fingers.

Strips of gaffa tape inside
the down jacket in case it
should get torn.

Polypropylene can be
washed in cold water.

Beards keep you warm in
the cold. Don't shave in
the jungle, a cut takes a
long time to heal.

Para cord for boot laces –
500 lb breaking strain.

Keep the five risk points
warm. Wrists, ankles and
head.

Geoff McKeown Steven Satow Jo Higgins

Clothing for extreme cold

Unless you are properly dressed it is both difficult and dangerous to take pictures in extremely cold conditions. You shouldn't have to rush around to keep warm, your clothing must do that. Your body uses up a lot of energy just keeping warm. Photography and clothing fabrics have both advanced recently. For instance, Gortex fabric is windproof, waterproof and 'breathes' so there is no longer that unpleasant build up of condensation inside the jacket.

The clothing here represents the extremes. Of course it can be varied to suit local conditions. Layering with zips is the secret.

Underwear
Lifa underwear. A good all-purpose underwear made of polypropylene. When you begin to feel cold, flap your arms and run on the spot to build up heat, and the polypropylene will keep the heat in. Sweat is absorbed through it into the next layer. Some people wear a string vest between the Lifa and the next layer.

Layer two
Polo neck by North Cape. Unzipping the neck is a simple way of controlling temperature. Helly Hanson pile fibre salopette and jacket. The overlap of the two keeps your middle warm. Helly Hanson also make a one-piece suit but this tends to be less versatile. If it is very cold, Rohan Hot Bags or climbing breeches can be worn as the outer layer.

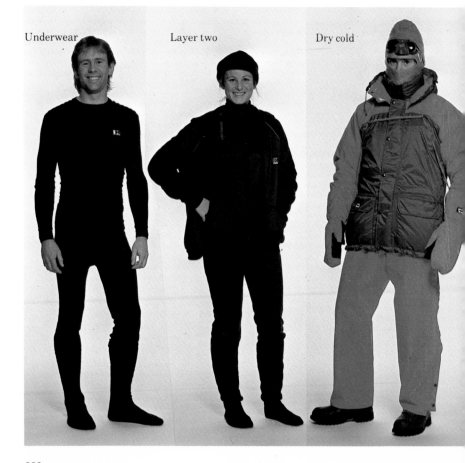

Underwear

Layer two

Dry cold

222

A close fitting woollen hat keeps your head and ears warm and keeps hair out of your eyes. Floppy hats and caps get in the way of the viewfinder.

Dry cold
Mountain equipment, down-filled, Gortex jacket, double zip for temperature control. Mountain equipment Gortex salopettes. Boots made by Sorels in Canada, with several choices of inner boot. There is not really a similar boot made in Britain. Waterproof outer mitts worn with a neck string so they don't blow away. Wool balaclava over a Helly Hanson polypropylene balaclava. Snow goggles with filled-in sides to protect your eyes from snow blindness.

Wet cold
The same underwear but a Berghaus Kang, Insulate filled, and strong Gortex on the outside. A really tough coat. The SAS wore them in the Falklands. Neck warmer, a polypropylene tube to stop the chill going down your neck, and a woollen hat. Koflach ultranylon boots with Berghaus Yeti gaiters, Lifa socks under Helly Hanson pile fibre socks. Wild country gloves. You can change film with these. Helly Hanson overmitts that flap open – all inside waterproof outermitts.

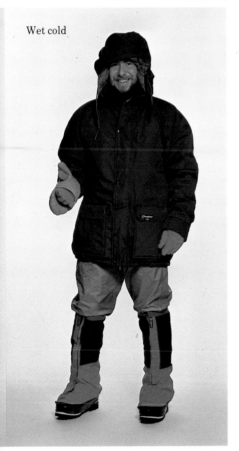

Wet cold

Be wary of buying most jackets, waistcoats and harnesses that are 'especially designed for photographers'. Most have been produced without any regard for what a photographer really needs. A jacket with a million pockets is useless – you can't remember where everything is. Avoid waistcoats and harnesses that make you look like a one-man-band.
Waistcoat Designed by a Californian photographer, beautifully made in Hong Kong with Egyptian cotton.
Jacket Still the best, a US Army combat jacket that is favoured by hundreds of professional photographers. Some are lined. They are comfortable, showerproof and reasonably smart!

Travel tips

Extreme cold

In extreme cold – below 20°F – you must use manual cameras, as batteries stop working very quickly in the extreme cold and the spares are extra weight to carry. Motor winds are no good because of batteries and because film becomes so brittle the motor tears it.

Nikonos III, the mechanical model, is ideal. If a camera is to be used in extreme cold the oil should be changed for one of a finer grade. Return to original grade for normal conditions. Stick chamois leather around the eyepiece of the camera to avoid metal sticking to the face in the cold – very painful. Wear a silk balaclava: if your face touches the camera the balaclava protects the face from contact with the metal camera.

In a blizzard you can't change films, but with three loaded bodies, one in each duvet pocket, a hundred pictures are possible. Filters are essential for protecting the lens because you need to scrape the snow off after each frame. Rewind very slowly – the cold makes film so brittle that it breaks very easily. Be careful when handling film, you can cut fingers very easily.

Never put your camera bag down on the ice, or it will freeze up. Keep film warm in cold boxes. The most annoying problem is condensation. Keep ordinary plastic kitchen bags in your camera case, and when you have finished shooting put the camera in a plastic bag, squeeze out as much air as possible and tie a knot in the neck before taking it into a warm room. The condensation then forms on the bag and not the camera. If you don't use bags, the cameras will get dripping wet, and the water in the camera will freeze immediately when taken outside, stopping the camera working.

Auto exposure cameras are useless in these conditions. Use a Weston mechanical meter and take incident light readings and bracket the exposures when possible.

Take a variety of film stock – exposure value varies incredibly from 500th sec @ f16 on Kodachrome 64 to 30th @ f2 on Ektachrome 400 within minutes.

Wear very dark mountain glasses to avoid eye damage. Compose roughly through the glasses, then lift the glasses and shoot.

A Pelican case is excellent for extreme cold: it's totally waterproof. Ours survived a capsize into the sea, and the equipment remained dry.

Extreme heat

The major problem in equatorial conditions is high humidity. Fungae grow on film and cameras, camera bags, straps, etc.

Keep cameras and film in sealed domestic plastic bags, along with several packets of silica gel (buy large packs from army surplus shops), and then pop them in the camera bag. We have had cameras – especially motor drives – seize up overnight from moisture finding its way into the camera bags.

Don't open film packs till just before you load the camera, and make sure you seal them in a plastic bag with silica gel immediately after unloading. The gel can be dried out periodically by a few minutes in a domestic oven.

For your own protection, the main thing to remember is sensible clothing. Never leave any cut or abrasion unattended.

Desert

In extreme desert heat cameras must not be left in direct sunlight for long. The expansion and later contraction can cause the lens elements to shift position and a loss of sharpness will result. Keep cameras in a dustproof silver case or cover your soft bag in tin foil. Never leave equipment in the boot of a car.

Clean the cameras at night and

repack your bag when it is cool. Film will stay cool all day if you keep it in a Kodak film bag containing a freezer pack; make sure you rezip the bag after use.

A camera wrapped in chamois leather at night will stay cool most of the day. Air conditioning causes condensation to form on equipment which is brought in from the heat.

Dust

If you are anticipating really serious dust problems a sealed camera like the Nikonos is the only safe answer. But with ordinary cameras a Pelican type waterproof camera bag and sealing the camera in a plastic bag certainly helps. Tape over all exterior exposed parts not in use such as flash synch, motor drive terminals, battery check button and levers.

Sea water

This is deadly on camera equipment. The best protection is a good insurance policy because if you drop the camera in you can only claim for a new one, unfortunately nothing can be done to repair it. If your camera is exposed to spray, wipe the metal work with a swab of lint lightly soaked in WD 40. Keep it off the lens.

Trekking

It is better to arrange your own trip in places like India – it is usually cheaper and more flexible. Better to buy your equipment at home and take it with you. To cut down on weight if trekking in a group, you can carry your own camera body or bodies and each take a lens and swap around as required. A 24mm, 35–105mm and a 300mm with ×1.4 teleconverter would do the job. If you can handle two or more lenses between the three or four of you, an 18 or 20mm and a large aperture (35 or 180mm) would be useful. A tripod is essential – take turns to carry it.

Planes

Take eyedrops, lip salve, moisturizing skin cream, aspirin, toothbrush, mild sleeping pills – take only when desperate, they make you feel shattered on arrival. Drink plenty of water to combat dehydration on long flights and very little alcohol.

Always change enough money (in small notes) to the currency of your destination at the departure airport to pay porters, cabs and buses, etc.

If there seems to be a row of seats free, wait till you see the door closed and then grab them. It's a race well worth winning on long hauls. Keep passport and pen handy for filling out immigration forms.

As soon as you get on board, start adjusting to the time in the country you're going to. Carry several lists of camera equipment with serial numbers for customs at home and abroad. It shows efficiency and a concern for a foreign country's laws.

Cars and children

Always book your car and pay for it before you leave home – it's cheaper and you don't risk missing out. Check the spare wheel. Never hire a car that is too small – even well packed luggage has a habit of spreading after a few days.

When travelling alone in your own car, you can take almost any gear you want. We put our camera bags on the floor at the passenger side and cameras with lenses attached on the seat, nestling in a rug or a coat so everything is immediately accessible. Never leave maps visible in the car, it's a sign that you're a tourist and possibly have valuables in the boot. Saloons are more secure than station wagons, as nobody can see in.

When touring by car with children, don't try to cover too much ground in a day. You need to allow time for them to exercise and to let off steam (we take a football along), or they will become

Travel tips

unbearable by 4 p.m. Set out early and start looking for a hotel by 4 p.m. – if you leave it too late, anxiety builds up and tempers flare. Take pillows and rugs for the children to have naps along the way. Children enjoy following the route on maps – encourage this as it helps avoid boredom.

Never travel anywhere without a change of clothes handy (tracksuits are easy), plus a swimsuit and towel. Remember to have a large bottle of fresh water handy in the car. A Sony Walkman is a good companion.

Equipment

Check your insurance policy (all the small print) to see exactly what you are covered for. Know exactly where every item of equipment is packed in your bag (routine). Safer to buy your film at home and take it with you. If you run out, check the expiry date on film you buy. Best to find a shop with a big turnover. Don't post Kodachrome home in the yellow packets: it's sometimes stolen and then resold as new film.

Carry photocopies of all your camera receipts for customs to check that duty has been paid (if it has). X-ray of film of 400ASA and faster *is* a problem, as proved by extensive research by the American Society of Magazine Photographers; insist on a handsearch of film or send it in the hold. Take repair and cleaning kit – especially tiny screwdrivers.

General tips

Beware of automatically booking package trips. If you shop around independently it is usually possible to find cheaper, more flexible and better holidays.

Check the travel periodicals, magazines that are devoted to finding the cheapest and most interesting deals all over the world. Read all the good guide books: *Fielding*, *Fodors*, *Michelin* and the Time-Life books

because they are visually aware of a country's potential.

Take care to avoid sunburn – there are some excellent sun screen creams on the market.

Beware of guides. Remember that pictorial advice from a nonphotographer can be disappointing. Therefore check it out yourself.

Don't promise prints to everybody you photograph. It's impossible to keep track and it leaves people cynical about photographers.

If you have to travel in hot and cold climates on the same trip, pack mostly for the hot climate and take good thermal underwear with you as it saves a lot of luggage space.

Women photographers must take care not to attract attention to themselves and risk offence by dressing immodestly or flashily. In Muslim countries in particular it may be wise to cover legs, arms and head. It is impossible to take pictures if you are the centre of attention; it can also be very dangerous. Don't blame others for your own ignorance and insensitivity. It is advisable not to wear jewellery when taking pictures.

Reassess your day's shoot each night – it's easy to forget what you have taken and repeat yourself. Plan each day. Don't be frustrated by what is impossible, concentrate instead on what is.

Always walk away from trouble – you can't win in a strange country. Be courteous, remembering that you are intruding into other people's lives. Don't give photography a bad name!

Legal

The most important legal advice for travellers is to remember that you are not at the movies, you are in someone else's country. If you get yourself into trouble because of your ignorance of the law, it is your own fault. For instance, in Iceland you require a permit to photograph nesting birds; it is

illegal in many countries to photograph airports, military personnel, even bridges and roads (South Africa). It may seem strange to us, but it's the law and it's up to you to know what not to do.

In most Western countries there is no restriction on photography in public places – but be careful about what is public and what is private property. Invasion of privacy laws apply to photographs of people on their own property, and in France, the house itself. Always ask first.

A signed model release form is required if you are planning to use pictures of people in ads or publicity.

Medical

When about to visit exotic countries make sure you take medical advice. Check that all your vaccinations are up to date. We never travel without tetanus and the gamma globulin (anti-hepatitus) jabs.

Take out an accident and illness insurance policy that will pay for you (and very important, your children) to be flown for treatment in an emergency.

Be careful of sunburn and sunstroke, wear a good sunhat and sunglasses, especially at high altitude. Take a block out suntan cream plus normal suntan creams.

Check with doctor or airline about which malaria prevention pills are appropriate for the area you are visiting – the situation is constantly changing.

After returning from tropical areas remember that many tropical diseases have a long incubation period. So please seek medical treatment for any illness (especially one with flu-like symptoms) that occurs even weeks after your return.

Don't eat fish when you can't see the water, or meat when you haven't seen it on the hoof (old adage for unhygienic areas, but still relevant).

Where water is suspect, never eat salads, or have ice in drinks.

Any food straight out of the oven in India or Africa should be safe, as germs are killed off by the temperature.

Salt loss from sweating leads to cramp. To avoid this, take sodium chloride tablets.

Frostbite affects the extremities. It is insidious because it can begin almost painlessly. Beware of touching metal (on cameras, for instance) and slowly massage any numb areas.

First aid box should contain eye wash and ointments, plasters and bandages, antibiotics, water-purifying tablets, glucose and salt, aspirin, travel sickness pills, antihistamines, insect repellent, calamine lotion, needle, iodine, alcohol, scissors and tweezers.

Repel 100 Maximum Strength is the best insect repellent we've found. A couple of drops will protect for 10 hours.

If you wear contact lenses or glasses, take a spare pair.

If you need treatment, carry a letter in the language of the country being visited.

Know your blood group, and carry the information on you.

Where to go when

January

Amazon Amazon Basin in the rainy season. The Rio Negro rises 30 feet, partially submerging forests. Orchids and rare blossoms grow out of half-sunk trees. Aerial interesting.
Austria Carnival on skis.
Belgium Parade of the Maji in Flanders.
Egypt The Pyramid of Cheops, largest of Giza Pyramids, early morning.
Italy Almond Blossom Festival of Agrigento.
Kenya Hell's Gate Pass, spectacular rock forms and wildlife.
Kenya The flamingo-filled soda flats of Lake Magadi.
Morocco Almond Blossom Festival at Tafrout.
Scotland Burn's Night celebrations (25th).
Scotland Up-Helly-Aa, Viking festival in Shetland.
Spain Two-day festival in Granada, commemorating liberation from the Moors in 1492.
Sweden Great Lapp Winter Fair in Jokkmokk.
Tanzania Serengeti National Park, migration season. Serengeti Plains have very good wildlife.
USA Eastern Utah, the Double Arch at Arches National Park and plenty of bizarre sandstone grotesques.
USA Snow in North American deserts (roughly an inch falls every year).
USA The Niagara Falls, in severe winter frozen into enormous icicles.
Zaire Deep in Huri forest waters of Ische River, fall from ledges of Mount Hugo.

February

Antarctica King Penguins; Davis (an Australian station) observe Aura Australis and other geomagnetic phenomena; extraordinary snow and icescapes on Wiencke Island in the Palmer Archipelago of the Antarctic Peninsula; Ross Ice Shelf – largest in world (200,000 square miles) – near McMurdo Sound salt deposits and glacial scenery.
Belgium Carnival season – best at Binche on Shrove Tuesday.
Bonaire Caribbean, animal carnival.
Canada Quebec City at dusk with frozen St Lawrence River.
Columbia The Santa Martas – snows of Sierra Nevada contrast with seaside tropical luxurience.
Denmark Carnival of Street Urchins throughout country, Shrove Tuesday.
France Fête of St Bernadette at Lourdes.
Hong Kong Chinese New Year.
Hungary Gypsy Festival at Budapest.
India Taj Mahal with full moon.
India Wildlife in Kaziranga Wildlife Sanctuary.
Japan Snow festival with ice-carving at Tokamachi in Japanese Alps.
Kenya Lake Bogoria – flamingoes flock to these alkaline waters and steaming geysers.
North Austrian Alps The Eisriesenwelt, ice caves.
Peru Island of the Sun – legendary birth place of the Incas – rising out of Lake Titicata.
Switzerland Mont Blanc – Le Mont in Chamoix valley tucked away beneath glaciered flanks.
USA Chinese New Year celebrations in Chinatown, New York.
USA North Carolina, the Appalachian Trail – Zionville valley.
USA Utah in the snow.

March

Australia 'Moomba' – 10-day festival in Melbourne.
Australia Northern Territories – the Olgas in autumn.
Bora Bora French Polynesia, a green tranquil island surrounded by reef and crystal waters of its lagoons – excellent for underwater.
Brazil Rio de Janeiro – the Carnival.
England Grand National, Liverpool.
France Battle of Flowers in Nice.
Greece Culmination of February's carnival in a parade with floats in Parta; impressive Greek Orthodox processions on Good Friday.
Holland Annual Keukenhof flower exhibition at Lisse in heart of bulb fields.
Hungary Spring festivals in Budapest.
Ireland St Patrick's Day Parade through Dublin streets; Gaelic football.
Italy Florence's Scoppio del Carro on Easter Sunday.
Japan Early spring at the Inland Sea; Shikoku – the Naruto Whirlpools.
Kenya Kilimanjaro, white in spring sun.
Malta Freedom Day (31st).
New Zealand Golden Shears sheep-shearing championships in Masterton.
USA Los Angeles, St Joseph's Day at San Juan Capistrano (19th), founded in 1776 and inhabited by flocks of white pigeons.
USA New Orleans, carnival climaxes on Mardi Gras – 41st day before Easter.
USA Washington for blossoms.
Venezuela The Angel Falls, the earth's highest waterfall, in rainy season.

April

Argentina Autumn colours; Tierra del Fuego.
Burma New Year holiday – carnivals.
Chile Lake Fagnano – mellow autumn hues.
Costa Rica Extensive jungle wildlife in Tortuguero's rain forest.
Costa Rica The three craters of Poa surrounded by satanic landscape.
Finland Vapunaatto Night (30th) – spring festivals.
France Bullfights, Roman arena at Arles, Easter fête in Biarritz.
India Hunt the Indian Lion in Kathiawar Pensinsula.
India The Lamasery of Tiske dwarfed by snow-capped peaks.
Ireland Irish Grand National – Fairyhouse.
Japan Nagasaki kite flying contest. Flower festival at Ito City (hot springs).
Jordan Petra the lost city; Wadi Rum desert and Bedouin people.
Manilla The walled city of Intramuros at Tagaytay on mountain ridge with view over Taal Lake and volcano.
Nepal Everest.
Peru Andes – Bosque de Piedras, forest of rocks.
Spain Corpus Christi processions, Seville, Toledo, Granada, streets carpeted in flowers.
USA Everglades – Pa-hay-Okee gives good view of sweltering mango forests.
USA Mojave Desert – ghost towns, wildlife and rain carpets of golden poppies.
USA New Jersey, Easter Parade on broadwalks; Atlantic City (cherry blossoms, dogwood and hydrangeas).

Where to go when

May

Alaska Icebergs at Wachusett inlet in Glacier Bay.
Australia Ayres Rock at sunrise.
Australia Bangtail Muster – Rodeo at Alice Springs.
Austria Vienna Festival.
China The Great Wall.
Egypt Son et Lumière.
Egypt Sphinx and the Pyramids of Giza before seasonal rain.
Egypt Western desert, driest part of Sahara, massive dune fields.
England Chelsea Flower Show.
England Kew Gardens spring display.
England Oxford, early morning May Day celebrations.
France Joan of Ark celebrations – Orleans and Rouen.
Hawaii May Day (Lei Day) at Waikiki Shell in Kapiolani Park.
Italy Sardinian Costume Cavalcade – Sassari.
Mexico Forest of Giant Cardon Cacti.
Papua New Guinea May Frangipani Festivals at Rapaul with Mardi Gras.
Romania The 'Kiss Fair' – Arad.
Spain Feast of St Isidro – top bullfighting – Madrid from 20th.
Turkey Festival of ancient amphitheatres of Epheseus, Perganum and Hierapolis.
USA Acoma, New Mexico – village 357 feet up, jutting out of sheer rock; grazing country.
USA Arizòna – Saguaro National Monument – cacti bloom.
USA Late May, Arkansas – Oklahoma Rodeo.
USA Louisiana – morning in fog-filled Atchafalaya Swamp.
USA May Day in Las Vegas and sunrise over desert.
USA Nevada – Wheeler Peak scenic area; five vegetative life zones, desert to alpine zone.
USA The Sandia Peak aerial tram. Altitude 10,678 feet – see New Mexico, Santa Fe and Rockies.
USSR Athletes parade – Red Square, May Day.

June

Egypt Sunset on the Nile at Luxor.
England The Epsom Derby.
England Trooping the colour, and the rehearsals.
Ethiopia Irta'Álē – one of several active volcanoes in Afar Triangle; aerial.
Hawaii Maui – Yosenute – a spectacular ravine; House of the Sun Volcano – moonscape and brilliant silversword plant; dawn on Hanoa Beach in Hana The Heavenly.
Hawaii The Na Pali coast – wild and uninhabited; Island of Kauai.
Iceland Midnight sun – sunset takes 4 hours.
Ireland Giant's Causeway.
Italy Tournament of the Bridge, Pisa.
Morocco National Folklore festival in ruins of Badii Palace, Marrakech.
Poland Midsummer 'Wianki' celebrations throughout country (23rd).
Portugal St Anthony's Festival, Lisbon.
Samoa Islands Colourful Independence Day celebrations (independence from New Zealand).
Turkey Istanbul Festival.
USA Alaska – Mount McKinley at midnight looming above Alaskan wilderness (21st).
USA Alaska Midsummer and Midnight Sun Festival.
USA Louisiana – river journey down Mississippi.
USA Valley of Ten Thousand Smokes with June colours.
USA Wyoming – Yellowstone National Park, 140 geysers; Minera Terrace at Mammouth Hot Springs; from air prismatic springs yield strange colours.
USSR Siberia – Lake Baykal, world's deepest lake, fed by 330 rivers and flanked by snowy cliffs.

July

Alaska Aerial – floodplains in central Alaska (ox-bow lakes).
Antigua July/August midsummer festival.
Australia Ayres Rock; dawn, rose; midday, red hot ember; sunset, blood red.
Australia Divers' rally, Heron Island, Queensland.
Australia Kimberley – unique red mountains, gorges and cavern by camel safari.
Austria Salzburg Festival.
England Henley Royal Regatta.
France Bastille Day (14th); Great Celtic festival, Quimper in Britanny.
French Polynesia Bastille Day (14th) – two weeks of festivities on Bora Bora, Tahiti.
Holland 15 windmills in action every Saturday at Kinderdijk near Rotterdam.
India Monsoon.
India Onam Harvest festival; Kerala, snake boat races.
Japan Sunrise at 12,388 feet – Mount Fuji.
Norway Viking festivals at Stiklestad near Trondheim.
Singapore Harbour.
Spain Fiesta of San Fermin in Pamplona with running of bulls.
USA Alaska logging championships at Sitka; Loggers' Rodeo.
USA Dream lake in Luray caverns.
USA Monterey Rodeo Month – Festival Rodeo in San Juan Batista.
USA Nevada and Utah great salt lake desert.
USA New York Fireworks on city's rivers and ballfields in honour of independence.
USA Surfers' sunrise at Laguna, California.
Yugoslavia Moreska Sword Dance in Korcula (27th).

August

Australia (Victoria) Golden Wattle Festival, Maryboro, ablaze with the yellow
 blossom of gum trees.
Australia Alice Springs – Henley-on-Todd Regatta – mad!
Australia Great Barrier Reef.
Australia The Shinju Matsuri Festival, Broome – includes the Corroborees –
 Aboriginal festival.
Canada Aerial – prairies at harvest.
Channel Islands Battle of Flowers.
Egypt Asyut – very attractive town.
England Cowes Week.
Fiji Islands Hibiscus festivals.
India Pashkar Cattle Fair – very colourful cattle fair in Rajastan and camel races.
Italy Palio della Contrade – medieval horse races in Sienna.
Japan The Aura Odori Festival – colourful display of public emotion, Tokushima City
 (15th).
Marquesas Islands Hiva-Oa, deathplace of Paul Gauguin, inspirational vistas,
 especially Bay of Puaniau; Tahuata – village of Vaitahu.
Mexico Taos.
Norway Fjords, e.g. Geiranger Fjord with lush summer colours.
Scotland Edinburgh International Festival.
Spain Festival in honour of St Lawrence in the Escorial, Madrid.
USA Cascade Mountains – aflame with vivid Alpine flowers.
USA Colorado – Grand Canyon glows red at sunset.
USA Mount Tamalpais State Park, looking east towards San Francisco Bay.
USA Nightfall on Sandstone Stacks on Washington coast.
Wales Welsh National Eisteddfod.
West Germany Oktoberfest – Munich Beer festival (into September).
Yugoslavia Dubrovnik Summer festival – country's main cultural event.

Where to go when

September

Borneo Rain forests – massive variety of strange plant, insect, and mammal activity.
Ecuador Cotopaxi – very active snow-capped volcano only 50 miles from Equator.
Egypt Elephantine Island, on Nile near Aswan.
England The Horn Dancers of Abbots Bromley.
Haiti Late summer in Port-au-Prince – city of contrasts.
Holland Opening of Dutch Parliament by Queen in golden coach, The Hague (3rd Tuesday).
India Dal Lake – vale of Kashmir.
India Harvest in the Kashmir Valley.
Ireland International Folk Dance Festival.
Morocco Moulay Abdauah Moussem in Eljadida – splendid fantasias.
New Zealand Cherry Blossom festival, Alexandra.
Scotland Highland gathering in Braemar.
Tasmania Island of the Dead in spring.
USA Arizona – Painted Desert – fantastic forms and colours.
USA Colorado – Mesa Verde National Park – stone cliff houses built 1,000 years ago.
USA Lee, New Hampshire Fair – all-American and unpretentious.
USA Nevada – Monument Valley in thunderstorm.
USA Rocky Mountains – Glacier National Park – seasons seem sandwiched together.
USA Washington coast at low tide – bounty of colour and shapes.
Zimbabwe Victoria Falls.

October

Australia Northern Territory – extraordinary wilderness – Alice Springs, Darwin, Kakadu National Park, Alligator River.
Australia The Longitudinal Dunes of the Simpson Desert – parallel and red; the parallel valleys of the MacDonnell ranges – an oasis of colour in December after rain.
Borneo Forest canopy penetrated by jagged spires of dolomitic limestone.
Chile Spring on Lake Fagno, exotic plants and scenery.
Chile The Atacama Desert, Valley of the Moon; very weird – driest place on earth.
China Boat trip down River Li. Hill of Folded Colours; the Karst landscape of Guilin with beautifully coloured limestone pinnacles; osmanthus tree in autumn splendour.
Denmark Autumn in Danish woodland – the red stag.
Egypt Cruise down Nile.
England Blackpool Illuminations.
Hawaii Aloha Week – a concentration of local colour.
Ireland Great October fair in Ballinsloe, Co. Gallway – the world's oldest horse fair.
Italy Celebrations in honour of Columbus – Genoa.
Japan Nagasaki Suwa Festival – very colourful.
Portugal Great religious pilgrimage to Fatima (12th and 13th each month).
South Africa Stellenbosch in Cape in spring.
South Africa The Garden Route.
USA Fall foliage festival in Warner, New Hampshire, and fall festivals in Vermont.
USA The Great Smoky Moutains – shrouded in mist; great variety of tree colours.
Zaire Wildlife in Kahuzi Biega National Park.

November

Australia Alice Springs Festival week.
Brazil Rio Negro meets Amazon at Manans – aerial, and rain forests.
Chile Aerial of Cape Horn.
England Brighton vintage car rally.
England Fountains Abbey and Royal Studley in autumn colours.
France Les Trois Glorieuses – celebrations in honour of Burgundy wine.

India The steaming palm-fringed backwaters of Kerala.
The Maldives Baros Island tiny tropical paradise.
New Zealand Milford Track – finest walk in world.
Sahara The volcanic rocks of Ilamen range of Basalt peaks – desert sculptures.
South Africa Spring in Cape Town.
Sri Lanka Nuwaraeilya – haven in the Highlands.
Tahiti Day of Thousand Flowers.
Tanzania The wine red waters of Lake Natron stained by seasonal bloom of algae – many flamingoes.

December

Australia Start of Sydney to Hobart yacht race.
Bali Lush and beautiful with continuous colourful carnivals.
Bangkok Floating markets, temples and waterways.
Burma The Shwe Dagon Pagoda and trip down Irrawaddy River.
Canada Labrador – seals in ice floes and weird-shaped icebergs.
Caribbean Bonaire – magnificent coral reefs.
Chile Navarino Island – world's southernmost town.
England Blazing Tar Ceremony, New Year's Eve, Allendale Town.
Ethiopia Mount Dallol – a colourful array of salt deposits.
Finland Midwinter's day at noon in Finnish Lapland.
Iceland icy chambers within Glacier Kverkjökull formed by subglacial volcano.
India Bathing in the Holy Ganges at dawn in Varanasi.
Mexico Chichen Itza – ancient pyramids and temples.
USA New York – Times Square for New Year countdown.
Western Samoa Christmas, New Year – unique atmosphere.
Zaire The mist-shrouded peaks, glaciers and plants of bizarre sizes near Wasuwameso.

Most photogenic game parks

Brazil Araguara, enormous wooded massif, levelled forests, Amazonia at its best. **Iguacu National Park,** contains Iguacu River's magnificent waterfalls.
Canada and USA Waterton – Glacier International Peace Park, grizzly bears, black bears, moose, sheep, mountain goats.
Canada Wood Buffalo National Park, the wood buffalo, plains buffalo, extremely rare American crane.
China Wanglang in Szechwan, giant pandas.
Guatemala Tikal, forest animals, jaguars, pumas, American tapirs, significant remains of Mayan civilization.
India Assam, The **Kaziranga,** very photogenic, to be crossed by elephant, rare unicorn rhinos, elephants, tigers, bears, leopards, boars, various species of deer. **Great Forest Wildlife Sanctuary,** home of surviving Asian lions.
Kenya Lake Nakuru, bird sanctuary and mammals. **Masai Mara Game Reserve,** enormous number of animals.
Madagascar Tsingy du Bemaraha, magnificent tropical primary forest, wildlife and flora.
RSA Kruger Elephant, giraffe, white rhino, hippopotamus, lion, leopard, 17 species of antelope.
Tanzania Serengeti, Thompson's and Grant's gazelle, zebra, elephants, buffalo, giraffe, black rhinos, eland, antelope, lions, cheetahs, leopards.
USA Alaska Arctic National Wildlife Refuge. Everglades National Park, Florida puma, cayman, deer, many birds. **Yellowstone.**
Zambia South Luangwa National Park, various and numerous animals, Thorncroft's rare breed of giraffe.
Zimbabwe Wankie Limpopo River and Kalahari's partially-wooded sands. Elephant, buffalo, black rhinos, giraffe, buck, zebra, lion, leopard, cheetah.

Glossary

Aperture
The hole in the lens that allows light to pass through and expose on the film when the shutter is open. The hole is variable in size which is measured in f stops.

Aperture priority
The auto mode when the photographer sets the aperture and the camera adjusts the shutter speed automatically to achieve correct exposure. When the aperture – the depth of field – is of prime importance to the photograph rather than the shutter speed.

ASA
American Standards Association rating of the sensitivity of photographic emulsions to light: the higher the rating, the more sensitive (faster) the film.

Auto
Camera setting for the camera to make automatic exposures.

Bounced light
Light reflected off a surface.

Centre weighting
The metering system in a camera where the exposure is taken off the centre of the film plane.

Clip test
Test processing of a portion of a roll of film to check exposure.

Cold colour
Colour strong in the blue end of the spectrum.

Computer flash
Flash unit with its own built-in sensor which automatically calculates the correct amount of flash needed.

Crop
To cut in to a part of the subject leaving it incomplete in form, e.g. crop the top off the head of a portrait for a more dynamic appearance.

Cut
To rate a film at a lower (ASA rating) speed than the manufacturer's recommendation.

Cut processing
Reduce the development to compensate for overexposure.

Density
The degree of darkness of a transparency or negative.

Depth of field / depth of focus
The distance that remains sharp in a photograph from foreground to background, determined by the F stop of the aperture.

Fast film
Film with a high ASA rating: e.g. Fuji 1600.

Fast lens
Lens with wide aperture.

Fill in light / fill in flash
A light used to lighten the shadow areas of a photograph.

Flare
Light reflected off a lens surface.

Focal point
Point in the picture that attracts or draws the eye to it.

Grad
Graduated filter.

Grain
Silver halide crystals of a film emulsion visible in a transparency or print. The faster the film, the coarser the grain.

Graphic; graphic effect
Making a strong design or pattern from the shapes, lines and colours in a picture.

Hard-edged colour
Colour that has extremely strong definition between colours in a photograph, emphasized by simple strong compositions.

Highlight
The brightest part of the photograph. Opposite exposure value of shadow.

Image priority
The point of interest or the main subject in a picture.

Incident light
The light falling on to a subject.

Incident light reading
A light reading of the volume of light falling on the subject. Taken by an incident light meter.

ND filter
Neutral density filter, used to cut down the volume of light. It has no colour of its own.

ND grad
Neutral density graduated filter.

Optimum exposure
The ideal exposure decided on by a camera set on program mode.

Positive shapes/ negative shapes
Positive shapes are those formed by the main subject, negative shapes are those formed by the spaces between picture shapes and the edge of the frame.

Push
To rate a film at a higher speed than the manufacturer's recommendation.

Push processing
Increasing the development to compensate for underexposing the film, i.e. ED200 pushed to 400 ASA = underexposure of 1 stop requiring development increase of 3 minutes in first developer.

Reading
The exposure reading or calculation.

Saturation, saturated colour
Each colour at full strength, as opposed to 'washed out'.

Short lens
Wide angle lens.

Shutter
The mechanism that controls the length of time that the light is allowed to expose on the film.

Shutter speed
The auto mode when the shutter speed is the main priority and the camera automatically adjusts the aperture.

Slow film
Film with a slow ASA rating: e.g. KD25.

Slow lens
Lens with small aperture.

Softar
A soft focus lens or filter. The trade name of the Hasselblad soft focus lens.

Spot reading
An exposure reading taken from a small portion of the photograph, by either the spot meter facility on some cameras or a spot meter.

TTL
Through the lens metering.

Uprating
Lifting the ASA rating of a film above the manufacturer's recommendation – same as push.

Warm colour
Colour strong in the red end of the spectrum.

Washed out
Colour that has no saturation, is too light; usually caused by over-exposure.

Acknowledgements

We would like to thank Bryn Campbell who passed on his experience to us after his assignment as photographer on Sir Ranulph Fiennes' circumnavigation of the world via both poles.
Peter Gittoes and Mathew Lutos of Barclays Bank
Sunday Times
Time Magazine
Time-Life Books, London
Bill Cummings of Keith Johnson Photographic
Graham Wainright and David Halliday
Leeds Camera Centre
Ralph Young, Lee Filters
DFDS Ferries
All at Tecno, Kensington
All at Alpine Sports, Kensington
All at Hornblower
Justin Pumfrey for assistance and compiling Where to go when
All those who helped in many different ways, especially David Scotland, Steve Satow and Stephen Julius

All the photographs in this book are available for most uses from:
Tony Stone Worldwide,
28 Finchley Road, London NW8 6ES
Tony Stone Worldwide,
7 Ridge Street, North Sydney, NSW 2060, Australia
Tony Stone Worldwide,
PO Box 1659, Johannesburg, South Africa 2000

Index

Entries in **bold** are main entries, those in *italics* appear in captions to illustrations.